Anna Comnena

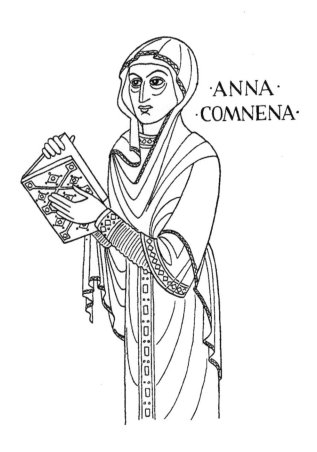

·ANNA·
·COMNENA·

# Anna Comnena

## *Naomi Mitchison*

with an Introduction by
Isobel Murray

Kennedy & Boyd

Kennedy & Boyd
an imprint of
Zeticula
57 St Vincent Crescent
Glasgow
G3 8NQ
Scotland

http://www.kennedyandboyd.co.uk
admin@kennedyandboyd.co.uk

*Anna Comnena* First published by Gerald Howe Ltd,
London in 1928.
The frontispiece portrait drawn by J. Gower Parks from
contemporary sources.

'Yet, instead of the simplicity of style and narrative which wins our belief, an elaborate affection of rhetoric and science betrays, in every page, the vanity of a female author.'

GIBBON on Anna Comnena

# REPRESENTATIVE
# WOMEN

MRS ANNIE BESANT
Geoffrey West

BIANCA CAPPELLO    Clifford Bax

APHRA BEHN    V. Sackville-West

ELIZABETH CHUDLEIGH,
DUCHESS OF KINGSTON
Beatrice Curtis Brown

LADY HESTER STANHOPE
Martin Armstrong

SARAH CHURCHILL,
DUCHESS OF MARLBOROUGH
Bonamy Dobrée

ELIZABETH BARRETT BROWNING
Irene Cooper Willis

MARY SHELLEY    Richard Church

RACHEL                James Agate

LETIZIA BONAPARTE
(MADAME MÈRE)
Clement Shaw

ANNA COMNENA  Naomi Mitchison

MRS MONTAGU           John Busse

CHRISTINA OF SWEDEN
Ada Harrison

LA DUCHESSE DU MAINE
Francis Birrell

*Each 3s 6d*

# Introduction

Biography is not a literary genre that Naomi Mitchison is particularly known for. Readers are more likely to identify her as a novelist, or particularly a historical novelist, a story teller, the author of children's books, or of several volumes of autobiography. She was an inveterate inventor of stories. But she did write this biography of a real historical figure, *Anna Comnena* (1928). Also a short biography of pioneer woman doctor Elizabeth Garrett Anderson (1931). And with Richard Crossman she wrote a brief life of Socrates, in a 'world-makers and world-shakers series' in 1937. Much later she wrote a moving life of Bram Fischer, heroic white champion of the South African anti apartheid movement (1973). She wrote two children's books in 'The Young' series, *The Young Alexander the Great* (1960), and *The Young Alfred the Great* (1962); and in a 'Then and There' series she wrote another children's book, *Alexander the Great* (1964). And in yet another series, 'Heroic Retellings from History and Legend', she published *African Heroes*, eleven short biographies of important African figures, in 1968. If she were allergic to recreating real instead of fictional characters, she would hardly have returned so often to this form.

As in her historical novels, she was always intent on creating the known world of the character she presented, the place in history, in geography, the socially learned beliefs and manners, as well as her central concern, the individual. And she often had an educational or political reason for presenting the figure she chose to the audience she was writing for. The first section of any biography for her was always 'background', and it was at least as important as any other chapter, no mere perfunctory scene-setting. So what about the very first of these, *Anna Comnena*? She wrote it for a series edited by Francis Birrell,

a London bookseller, called 'Representative Women'. That this was a common fashion in publishing at the time can be seen by consulting the list above. Other volume titles in this series include Mrs Annie Besant, Aphra Behn, Lady Hester Stanhope, Rachel and Christina of Sweden, all nearer the reader's world than the eleventh century princess of Constantinople. Why did Mitchison fix upon this rather obscure and unknown character, so far from the everyday, apparently so far from 'representative'? Here is where that 'background' chapter establishes a link.

Mitchison was born in 1897, in a settled and privileged world of British intelligentsia. She was being guided and trained, against her own desires, into a world of young ladyhood, where usage and custom were supposed to guide every step of the way. It was a world which seemed to have been soundly established, almost forever. She was going to 'come out', a little early, in the summer when she was sixteen. Instead, it was war that broke out, world war, and the world changed forever. War made a tremendous impact on her. She grew up suddenly, got engaged and married, became a VAD nurse, treated shocking wounds in a London hospital, nursed her new husband with a life-threatening wound, and learned through the cruel deaths of many, many friends that the old world had not been everlasting, that the new one was broken and unpredictable, that new values and ideas were necessary in facing the new and unknown world that faced her generation – and everyone else.

In this biography, set in Constantinople, Mitchison presents a dying world not unlike the apparently static civilisation in pre war Europe. The post war world was still changing, and declining: economic crises and fearful new political movements were making themselves known, movements that the author warned about in ringing terms, in novels like *We Have Been Warned* (1935)

and *The Blood of the Martyrs* (1939), in a book of anti-fairy tales like *The Fourth Pig* (1936), and in a book of personal philosophy like *The Moral Basis of Politics* (1938). Is the current civilisation as doomed to destruction as was Anna's Constantinople? Perhaps that doomed, always backward-looking civilisation mirrors ours, in ways we can learn from.

Mitchison chose to centre on Anna Comnena, whose very name is unknown to most people today. The typical two-line description in contemporary reference books says that she wrote a biography of her father and that she tried to kill her brother, first female historian or would-be murderess. Let me fill that out just a little. Anna Comnena was a princess in Constantinople (1083-1148). In years where the throne of the Eastern Empire was regularly fought over by ambitious princelings, Anna's father was Emperor of the East (1048-1118). In a competitive world, she had a really good title to succeed her father, and in her childhood she was betrothed to another possible heir, the young and beautiful Constantine: the pair had a glittering future. But sources agree that when her parents went on to have a baby boy, John, all these bright prospects for the ambitious child Anna were destroyed, and Anna conceived a lasting hatred for her brother.

But Mitchison is by no means content to tell us this family story. Her book begins with a chapter called 'Background', which boldly sketches Mitchison's version of the then known world: the remains of the Roman Empire in the East, centred on Constantinople, standing, ready or not, between Europe, which she sees 'like a tree in bud' (10), and Asia, 'near and menacing, bursting with the new life of Islam, a spear-head against Europe'. (15). Mitchison's is a breath-taking and very confident exposition of a world view, which will place Constantinople for us in history and civilisation, and show that it is at the end of its power.

Her desire to disturb our assumptions is manifested in her first sentence,: 'There are no Dark Ages in historic Europe'. If Constantinople can last long enough, it will allow the new life of Europe to bud and blossom, to form something ever forward-looking, while the people of Byzantium only look backward. 'We, like the Byzantines, are living at the end of an epoch, and must beware of rules'. (22) 'Anna Comnena liked rules', and personified the devotion to court life and proceedings that were at the centre of every day's ceremonial: she is representative of her civilisation in her tendency to look ever backward.

Mitchison calls for vivid, generalised history, even if inaccurate in the odd detail, such as she writes here, rather than the minor-fact dominated intricacies of post Great War history:

> And perhaps for this generation whose pride was so knocked out of it between 1914 and 1919, that is the only way to work, and they shall inherit the earth. (21)

Here comes her statement of intent:

> I believe she knew more or less what a historian ought to be like. But somehow she did manage to write – as history – a curiously bad history book. Sometimes one even suspects her of knowing that – by moments. Certainly not always, or for the most part; when she is really in full sail no winds of doubt are allowed to buffet her sideways out of her course; but at times they did, I think, and show something truer than the elaborate modesties affected by most of the other historians of her century and round about it. I am afraid she was stupid. Yet it is just as well to be stupid if one is born into as doomed a civilisation as hers. (22)

Mitchison focuses on its deadness:

Anna Comnena was certainly a representative woman; but the thing she represents is dead, and some of this inherent deadness is bound to cling to her and all we know of her. Part of it is the same deadness that may be found by someone in the future clinging to us if we are ever dug up and written about. . ... And the other part of what she represents is dead too, because the Byzantines have gone past with little to give us, and even the nestlings of their double eagle are vanished or dying birds now. But I want to show Anna moving through her dance, a life-time of it, making at least one moderately clear figure partnered and glittering in the grand chain of Byzantine imperialism. (23)

Here we have a very unusual situation, author and subject living so close together, and largely contemporaneously: and from here on, Mitchison's biography mutates into a new sub-genre. She interweaves the lives of Anna's subject, her beloved father Alexius, of Anna herself, and of the splendid and static court and the imperial armies. Often, the author's view is indicated by a dry choice of words. She ignores two word-pictures of Alexius, one by Anna herself, in favour of a manuscript illustration:

Alexius, in a plain halo, talking firmly to God in a superior one. He is frowning, with deep furrows over and under his eyes; his beard is short and black; God looks impressed. (27)

In all the rivalry for the Empire, many a one had his eyes put out as a punishment for ambition, but according to the author, 'Alexius had got the better of his various rivals for the purple through sheer merit . . . And it was as well for the Empire that this was so.' His chief enemy was Robert Guiscard of Normandy and Northern Italy, 'the villain in chief of Anna Comnena's history, whom she is never tired of describing with more and more delighted

horror.' (30) Robert had a son, Bohemond: for Anna 'the typical barbarian, more powerful even than his father. He stands for the antithesis of all her standards, and in a way she sees this and respects it.' (32)

All this before Anna was even born! She had some hard tasks, when she came to write, as Mitchison shows here, focussing on both father and daughter in turn:

> All through his life the Emperor Alexius kept on losing battles, yet somehow making good. The losses were the fault of his lack of men or materials, seldom due to any fault of his own judgment or military skill. He escaped the consequences time and again with amazing brilliance of stratagem or diplomacy, and this was all to his credit. But it was unfortunate material for his biographer. Poor Anna was so happy in describing her father's rather few victories! She must have found it trying to have to write so often about honourable retreats. (32)

We must not look to Comnena for unbiased history. All her work is coloured by her great love and admiration for her father, and by the prejudices and set ways of thinking of her time. She tends to glorify her father and his family, but even so her familiarity with public affairs and her access to the Imperial archives give her work great value to historians. When Mitchison fears she was stupid, this is not a simple negative criticism. After that on Alexius, all the chapters are headed by men's names, Constantine, the youthful ex-fiancé; Bryennius, Alexius' faithful servant, who began to write his life, and husband to Anna, who completed it; Bohemond, son of Raymond and arch-villain, and, finally John, the younger brother who succeeded to the throne, to Anna's disgust but Mitchison's approval. This is only what we should expect: although women at court received equal education, very good for their day, they would not expect equal recognition – and Mitchison

indicates how often they nevertheless manipulated events behind the scenes. Anna often plays down her own part in events, even omitting her own children from the story! It is Alexius' story she is setting out to tell, and it is a tale of battles, defences and diplomacy. The Empire's place, between Europe and Asia, was rarely peaceful, and Alexius was constantly fielding ambitious aspirants to it nonetheless. One of his chief aides in this was Nicephorus Bryennius, Anna's husband, whom she describes almost as idealistically as she does her father. Mitchison comments, 'Anna exaggerates, as usual,' describing him as 'an excellent second-rate always' . . . He wrote worse history than Anna, but it is quite conceivable that she thought it better.' (52)

> Alexius, aware of his limitations, trusted and favoured him. Anna finished her growing up after her marriage and was probably much influenced by him; but he never changed her at bottom, though I am certain she did her hair the way he liked it. (53)

Mitchison sees Bryennius as representative of his time and social class – the best of it – as Anna was a representative woman. The author's laidback feminism shows here:

> If women are to be kept behind bars it is silly to compromise about it as the later Byzantines did and allow them to be intelligent beings at all. It must lead to discontent and when possible violent ambition. One sees all her predecessors in Anna; much of her life stands for them all. (57)

They married just before the First Crusade. Here, as elsewhere, Mitchison's overview is much more help than Anna's account. She tells us,

during his early troubles Alexius had certainly asked for help in the West. . . . But the last thing he wanted or asked for was half Europe flung at his head in a wild Crusade, even though their avowed enemy was his enemy too. Allies and enemies are so dreadfully apt to get muddled up in the stress of the moment. (53)

His chief opponents were Robert Guiscard and his son Bohemond, but when Peter the Hermit called for the First Crusade, life got even more complicated.

Anna's history is virtually structured round the contrast between Alexius and Bohemond. Writes Mitchison:

sometimes it almost gives one the feeling of a single combat. This is her central idea, her unity; it is through this that she can claim her tiny degree of kindred with Thucydides (65)

Intriguingly, some of the most vivid and exciting writing comes when these protagonists escape defeat. Alexius is presented as the more heroic and active, even in defeat, in a tale Anna must often have heard in her childhood. She relates it in thrilling detail in chapter 2, establishing here his (uncharacteristic) flair for derring-do. Errol-Flynn-like, the emperor flies from the French along a mountain path known as Wicked Way. He is surrounded by foes, but his gallant horse 'reared up and with one great clattering bound was on the hillside above them' (33). Apparently safe, he suddenly encounters another band of French soldiers intent on taking him prisoner. Alexius picked out their reader, charged and wounded him. While his followers rushed to their leader, Alexius broke through and with a bound he was free! (33)

The balancing story of Bohemond in chapter 5 is inevitably considerably less glorious. As usual, Mitchison communicates different views simultaneously:

Bohemond was besieged in Antioch by the Emperor's Generals and decided he must escape and get back to Europe; the way he did it seems almost too good to be true. He had the rumour of his own death started, and then went off inside a coffin surrounded by mourners, on a galley which was allowed to pass freely through the Greek fleet. Anna makes it all very convincing by explaining how he had a dead and much stinking cock shut up with him so that there should be no suspicions, and goes on to explain how this reaffirms her certainty that there is nothing too nasty and difficult for barbarians to do when they are once set on it. (72)

Now the major feuding centres inside the family. Anna's mother Irene, and Anna and her husband take sides against her brother John. Anna becomes more and more ambitious and hard, as her father becomes gravely ill, and her mother looks to depose her own son, the rightful heir, according to the way of the times. Although Alexius has come in recent years to depend more and more on his wife Irene, it is not clear who will succeed him at his death, and he gives nothing away.

Anna's account ends with a fine description of the Emperor's deathbed, which Mitchison finds moving and authentic:

One of the few bits of really adequate narrative in which she is herself an actor; it has dignity and pathos, but is yet not copied from any great model. Sometimes it almost comes near to real tragedy. (88)

In her account she stands beside her father with a finger on the failing pulse, with her sister Maria trying to shield the Empress from seeing too much.

But Irene, sobbing and screaming, threw off all the ornaments of an Empress, cut all her hair, and even before he died was all in black. (87)

A more malicious account has John bending over his dying father weeping – and taking the ring off his finger, and hurrying away with it. 'Nobody can tell for certain.' But Mitchison's sympathies were always with John, whom she claims was an excellent ruler; 'one of the justest and most competent Emperors there had ever been on the throne of Constantinople.' (91) For Anna, he started as 'an unattractive but plausible baby', and declined ever after. Within six months of their father's death, Anna arranged a vast plot to assassinate John and put her own husband in his place. Mitchison reckons it would probably have succeeded but for Bryennius himself. It is said he arrived late:

> If he did one suspects him of having done it on purpose; he had never been entirely ruled by Anna and Irene; he asserted himself just in time, and refused to become a crime-stained Emperor just because his wife so much desired to be an Empress. (90)

Soon after, Bryennius died, and Anna was left to glorify her friends and condemn her enemies in a fascinating chapter of Byzantine history. In 1143 Brother John was killed. Mitchison's final word on her earliest of women historians can only be speculative:

> But no one knows what she thought of that, whether her long-twisted mind was still bitter enough to be glad, or whether possibly she was by that time good enough historian to see what the Empire had lost in John. (93)

*Isobel Murray,*
*November 2009*

# ANNA COMNENA

## (1083—1148)

### I

T H E R E  A R E  N O  D A R K  A G E S  in historic Europe.
They have been put conveniently between the Rome that still
spoke good Latin and the England that had begun to speak
understandable English : rather a long gap.   In any given
country there may have been darkness for a time, tracts of
years of which one can say little but that such and such a king
reigned, most often bloodily ;  but even so it is usually plain
that, when the country one is dealing with comes out again
under the beam of knowledge, certain things have grown and
advanced : learning, beliefs, humanity and decency.   And
the light is never quenched for all Europe at once.   Even
at the worst we know in more or less detail what was happen-
ing in and about Constantinople up to the beginning of the
thirteenth century.   It is not always a very pretty or edifying
picture, but much of it is at least as clear to us as our own
grandmothers' time.

We are apt to think of Constantinople as not Europe.
This must be partly because it has been so definitely assimi-
lated to Asia under the Turks, because now it is not a
European city whatever our political views may induce us to

feel it ought to be. And partly, too, because before the
Turks had any foothold there, our own Northern ancestors
looked upon it as a strange and magic place beyond the
boundaries of their world. Yet we must remember that once
it was a good Greek city-state, founded by Megara in the
period of her seventh-century greatness. But that was twice
as far from Anna Comnena's time as her time is from us.
She was a princess of Constantinople. Her family began to
come into power in the middle of the eleventh century. We
have to try and place the Constantinople of that age with
regard to the rest of Europe.

All this rest of Europe was like a tree in bud. Since
then the tree has blossomed and borne the fruits of good and
evil ; we cannot see what is happening to it now, whether it
is withering to death or whether it will bud again. But,
looking back to that eleventh century, it seems to us full of a
precarious new life. The daughter languages of Latin were
forming themselves to be used by poets and chroniclers ;
everywhere men were beginning to peer about them for some-
thing fresh, were tentatively throwing off their old beliefs ;
a few more generations and Avril would be fully come. Yet
with all this, thousands of men and women of the time were
expecting, in dread and seriousness, the end of the world.

All over the earlier civilised parts of Europe, except where
recent large wars had broken the cities and retarded growth,
the same thing was happening in different forms. The
monasteries were ceasing to be merely refuges ; they were
often already little centres of learning and art : touched by
the unhappiness, the sense of time passing, that Rome had
left and which would develop later into the desperate, cruel
gloom of the middle ages when all logic was pressed to the

service of a pessimism based on experience : but also touched
by the Spring fairies who leapt out to reclaim the woods as
the Gods left them, and turned men's eyes gently on the
wild things, the fawns and the thrushes and the primroses :

> Struunt lustra quadrupedes,
> et dulces nidos volucres,
> inter ligna florentia
> sua decantant gaudia.

This way some of the monks looked out of their cell windows.
And some left those cells to wander about the world, the
very first of the Goliards, for the songs that came into their
heads were no longer of any heaven near or remote, but
songs of that world and themselves in it.    Craftsmen in ivory
and boxwood, gold and enamel, were beginning to find new
forms ; the church builders grew a little more daring every
generation.    Also there was a new social order starting,
violent and generous, not founded on a slave state though
still including slavery, carrying in it perhaps all the evil germs
of feudalism and the age of faith and chivalry that was ulti-
mately as bad for women and the poor as anything that has
been before or since ; but yet terrifically alive, looking out
on the universe as it was known with new eyes, and thinking
and speaking newly of eternal things.

Inevitably France was the centre of all this, the easiest
climate for beauty, where grapes and apples both ripen happily.
A king held his court in Paris, and the whole land was full of
ruling houses, savage and intelligent and feeling out for loveli-
ness and truth.    The divine curiosity, which never quite
leaves France, was there then ; they were the first of the bar-
barians to set up schools where a few, at least, of the young

nobles were taught their letters and even a little classics and arithmetic. Latin was still the natural tongue for any learning, and the singers' tongue too, but a very flexible rhyming and chiming thing in the mouth of Baudri or Sigebert of Liege.

Spain then was just in the throes of the break-up of the Caliphate. For a long time it had been divided between Arabs and Christians, the former civilising the latter, teaching them agriculture, new and exciting forms of building and decoration, dozens of different arts and crafts, ceramics, fine weaving, leather and metal work, paper and glass making, and, still more important, medicine, astronomy, mathematics and music. The Caliphs and many of the wealthy families had large libraries—books at last written on linen paper ; poetry was the fashion in Islamic Spain among men and women too, trade had flourished vastly ; all this had been bound to influence the Christian kingdoms and was going to make them develop quite separately from the rest of Europe, even after the Arabs themselves had been driven out.

For centuries now, Italy had been torn about by wars and invasions, with scarcely breathing space enough to think of beauty. In theory at least Southern Italy belonged to the Byzantine Empire, but the north had been quite given up, and here the most exciting thing that was happening was the gradual development and fortification of the city states, Verona, Milan, Pisa and Genoa—Venice most important of all, where already the mixing of east and west, brought about by rapidly growing sea-borne trade, was beginning to produce the new forms of thought and art and government which were to be so astonishing in a few more generations.

In 1073 a new Pope came to Rome, Gregory VII, a

man not very learned and with little charm for the rich at least, but immensely enthusiastic, clear headed and competent in both thought and action. He saw that the Western Church was all disorganised, he used his supreme authority on kings and bishops alike. He was to have a strong and violent life, but so much occupied with his own end of Europe that he came into only incidental contact with the Eastern Empire.

Germany goes naturally with Italy in this Europe. Her Emperors were the Holy Roman Emperors, a succession of just and strong men, continually forging their state into a bigger and solider thing. Henry III had died, leaving a too pious widow, a young son, and for a time chaos. But the son had grown up as Henry IV, and after years of war and trouble had united Germany again, though most of Italy was lost. No doubt in the thick German forests dwarfs still forged gold, but edging and penetrating the pine and oak were the lands of the great monasteries, rich and learned, with their theologians and chroniclers—though Hroswitha the playwright was dead a hundred years.

To the East, Germany had difficult neighbours, heathen and curious Wends and such-like beyond the Elbe ; then unhappy Poland, always being marched through by one or another conqueror ; Bohemia still not entirely Christian in spite of good king Wenceslas ; and Hungary only just beginning to be a nation.

England had been having troubles of her own. Being an island, she was rather out of the centre of life, but Alfred had brought in a culture which had stayed, about the court at any rate. Edward the Confessor had just built a new cathedral at Westminster which must have been one of the

finest in Western Europe. There had been a reasonable
amount of justice and peace, and the larger towns were grow-
ing friendly to both art and commerce. But suddenly we
were attacked by two enemies at once, Norman and Viking.
Harold Godwinsson was killed at the Battle, for want of one
railway line ; and the land was possessed and laid waste by
the Normans, more cruel and not more cultured than those
whom they had conquered. Many Englishmen were forced
to leave their country then, and some went to Constantinople
to take service in the Emperor's Varangian guard. We hear
of one town with a complete English garrison.

As for the rest of Great Britain : in spite of many curious
survivals of savagery, there was a Celtic civilisation both in
Scotland and Wales. Ireland had long been civilised and
fairly sheltered. For several centuries now it had been pro-
ducing good poetry, both in Latin and Irish, mostly from the
monasteries, but sometimes too from the courts. This came
partly through scholarship, and partly—one sees that the
more because it was still rare in the rest of Europe—through
a romantic and delicate sense about both nature and people :
this is why in their books the saints are always made beautiful.

The kingdoms of Scandinavia were still further out of
things, but in the full swing of their own heroic age. Men
were free and equal, joyous and good fighters, and this is
one of the few times and places of history to which a woman
would not shudder at going back. They were masters of
beautiful ship-building, carvers and metal workers, and to
many of us their sagas are still among the most moving and
exciting things of all literature. By this time they were
mostly Christian, taking the ' New Faith ' very sensibly, on
the whole appreciating to the full the good of it, and leaving

the bad.   They too came to serve the Emperors of Mickle-
gard, kings and kings' sons among them.   Sometimes one
gets a double testimony about a battle or siege : once in a
Byzantine chronicle and again in a Norse saga.   Harald
Hardrada who was killed at Stamford Bridge had served the
Empress Zoe in Europe and Asia both.   As well as these
older countries, there were all the edges of Europe, where
the wanderers, still coming mysteriously out of that un-
explained central plateau that we have imagined for them,
were not yet settled.   All along the Carpathians and the
Danube, south towards Macedonia, west towards the Adriatic,
there were queer changing tribes and kingdoms with no stone-
built capitals.   They can be divided vaguely into groups,
Magyars and Bulgarians and Patzinaks, but we scarcely know
what they looked like, only that they spoke tongues which
have left no books behind them, and worshipped many and
sometimes dreadful Gods.   They were still sweeping across
Russia, though parts of it were settled, mostly along the
rivers, amber and fur routes older than any tradition.   Here
there were fortified towns, with painted churches, and plenty
of room for new kingdoms to be carved out and held by the
brave and cunning, whether Russian princes or Norse
Konungs, come south with their bands of companions to take
toll of gold and fine woven cloth and ermine skins, and per-
haps going to wander on, further south yet, and come out on
the frontiers as Varangians in the light of the romance we
know.

So much for the West.   But beyond was Asia, near and
terrible and menacing, bursting with the new life of Islam,
a spear-head against Europe, that had already, going round
by way of the fertile north African coast, pierced into Spain

and stayed there.    The states that once had stood between
were broken and crumbled with continual war.    Armenia,
after a thousand years of great fighting men, was being
smashed up, preparing to become an oppressed and hopeless
nation, scarcely aware of its Gladstones.    Palestine was in
the hands of the Seljuqs ; Egypt too had been quietly annexed.
At any moment Asia might come pouring in, terribly efficient
through its militarist and economical religion, invincible
through sheer force of numbers and faith, and annex Europe
too, so that no bud of the young Avril should come to
blossom.

     But between young Europe and Asia, though scarcely
conscious of it, was the remains of the Roman Empire, its
capital now and for centuries back definitely in Constanti-
nople, with Rome itself cast off, back to the Latins and their
Pope.    It was small enough, scarcely going more than five
or six hundred miles from the capital in any direction.    Its
northern boundary, often encroached on, was the Danube,
though on the Adriatic coast it went little further than
Durazzo.    All Greece belonged to it, and the Greek islands,
and about half Asia Minor; here it extended along the coasts,
taking in the trading towns, as far as Trebizond on the Black
Sea, and Antioch to the south, but inland the Seljuqs had
bitten the heart out of it.    Constantinople was the centre.
And the ruler of Constantinople, whether or not he wished
it, must guard the young Europe against Asia.

     They neither understood nor wished it.    Not one of the
Byzantines, priest or lay, of whom we know anything, ever
once looked at it that way.    For them, their trust was the
Roman Empire, that ancient wolf-born thing still alive,
though for the most part Greek-speaking now and almost

all Christian.   It was true for them that Asia was the enemy,
but western, barbarian Europe was, as far as it was anything,
hostile too ;  they were the rebellious Latins from the old
dropped-off provinces, first conquests of Rome in days further
back to them than their time is to us.   That was the way it
looked to them.   They could never have imagined how,
only some six centuries on, a certain barbarian curiously and
uncouthly named Gibbon would write of them :

   ' At every step, as we sink deeper in the decline and fall
of the Eastern Empire, the annals of each succeeding reign
would impose a more ungrateful and melancholy task.
These annals would continue to repeat a tedious and uniform
tale of weakness and misery ;  the natural connection of
causes and events would be broken by frequent and hasty
transitions, and a minute accumulation of circumstances must
destroy the light and effect of those general pictures which
compose the use and ornament of a remote history. . . . The
scale of dominion is diminished to our view by the distance
of time and place ;  nor is the loss of external splendour com-
pensated by the nobler gifts of virtue and genius.'

   But of course it is a disadvantage living at the end of a
great period of civilisation, still more so when the young
new period is beginning beside you, inevitably more interest-
ing to the historians of the future.   Even apart from them
(and—who knows ?—they may be ugly, crossed in love,
negligible . . .) it is bad for oneself : worst if one does not
realise it at all.   Some of us living now do realise it and try
to work and think, as best we can, for a future we cannot
know.   But not the Byzantines.   When one civilisation has
been going on for as long as theirs had, and altering so little
in essentials between one century and the next, men and
women are apt to be born old.   They are bound by an

                                    B

amazing weight of rules and prejudices and precedents, in
every part of life : in art and literature, in ethics and conduct,
most of all perhaps in social life and the politics of the State.
As we all know for ourselves, Europe is at present remark-
ably full of rules of one sort and another, stone walls against
which the unwary are constantly finding their heads or hearts
bumped, but, as far as one can judge, London to-day is
nothing to Constantinople in the eleventh century.

Dress and architecture, mirroring contemporary life more
faithfully than any other arts, give the show away.   Every-
thing was at its most stiff and elaborate—the dresses much
alike for men and women, equally hiding the typical shapes of
both, straight and long in heavy, glittering stuffs, woven with
plants and beasts, castles and crowns and religious symbols,
edged with pattern at neck and hem : very beautiful in them-
selves, but nothing to do with the people inside them.   Or, on
a plain weave, there would be embroidery of thick silks and
beads or jewels, precious metals or leather on leather.   Even
the animals chosen by the embroiderer were not the light and
fantastic gazelles of modern Paris, but elephants and camels,
as realistic as they could be made.   Jewellery was the same,
no small trifle of brightness to nestle between breasts or on
the throb of the throat, but solid squares of gold and enamel,
thick-coloured stones, polished and carved, but not yet cut
into facets.   Architecture followed dress in richness and
elaboration and lack of any gentleness or deviation from the
rules : as far from the soft, half human curve out and in,
the entasis of any row of columns from the smallest Hellenic
temple, as it was from the gaiety and leaping beauty of a
mediæval church.   Probably the poorer people's houses were
much as they have always been everywhere up to the last

hundred years or so : built without any special plan, of the
worst materials, cold in winter, hot in summer, subject to
fire or vermin or mere collapse from rottenness.    But
churches and palaces and noble houses were large and high
with galleries and staircases, marble columns and narrow
domes inlaid or painted, magnificent private bathrooms, doors
of scented wood.    Sanitation in Constantinople was still
primitive, depending on cheap, unskilled labour that could
be set to the filthiest jobs.    That accounted, also, for much
of the detail of the architecture, the remarkable ugliness of
much of the inlay and almost all the mosaic.    When men
are treated as cheap machinery their work will have the
qualities of cheap machine-made stuff.    Slave labour can
produce beauty : much of the building on the Acropolis is
slave-made : but it all depends on whether the slave is re-
garded as a ' boy ' or, more modernly, as a ' hand '—a thing.

The historical sense is a curious thing and rather rare ;

This was the time and place where Anna Comnena was
born, a princess, eldest child of an Emperor and Empress.
She was as unconscious as everyone else of the place in Europe
and history of her city and her civilisation.    We happen to
know about her because when, as we shall see, she was old
and out of the picture, she wrote the Alexiad, a history of her
father the Emperor Alexius who reigned from 1081 to 1118
over Constantinople and the Roman Empire.

The historical sense is a curious thing and rather rare ;
it postulates a different type of mind from the chronicler's.
It is arguable that it implies a moral point of view, and at any
rate it means, like any other art form, selection : an idea to
group the facts round and use as your test of which you will
take.    The chroniclers went straight on, and they make very
jolly reading, but at the end the reader's mind is left in

picturesque, but complete, confusion, because they had no idea of unity and because, on the whole, they were writing for themselves and not for the future nor in relation with the past.   I think most people feel, reading Thucydides' account of the fighting at Syracuse : ' This was written for me ! ' It is as exciting and moving as something told by a friend of his own greatness and suffering.   The real historian must be more or less conscious of his own place in history, whether he writes of the times he lives in or not.   He must not be frightened of the passage of centuries nor take them as a barrier against his ancestors or descendants.   He must think of it all as a whole, and be internationalist in time as in space. Patriot too perhaps, as again Thucydides was, but somehow not blinded by it, only able to show us his own State in the diamond clear light of love.   This clarity, above all, he must have, because, far more than any author of poem or romance or even stage-play, he is writing for unknown others.

Thucydides, I believe, expresses this sense more clearly and economically than any other historian.   After him, for the next few hundred years, there were others.   But when the times of the great classic historians are over, the thing only comes in patches here and there.   Many of the writers are delightful and full of good stories, but most of them have chroniclers' minds, or are propagandists with no feeling for clarity and truth.   Under the Byzantine Empire they were apt to be simply authors of more or less scandalous memoirs : they had at least a great wealth of material.

It is scarcely till the eighteenth century that this special sense appears again (though every mediævalist has his or her favourites) with more than one true historian, and one only Gibbon to the credit of England.   Lately our histories,

whether ancient or modern, have been hampered by a terrible
diffidence, worse perhaps since the War, about facts.  I speak
as reader, not writer ;  and how glad one always is when the
book one is reading comes straight out at one with a living
and probably inaccurate violence !  Let it be inaccurate.
Let the facts be re-edited in twenty years.  But in Clio's
name let it be as readable as a detective story !  Delightful
and exciting as it is, all this butterfly-chasing after little bright
facts, things to be pinned down and gazed at in their brilliance,
yet that is not the whole of history.  It seems to be en-
couraged by the feeling that the onlooker, the reader, should
be able to, and ought to, make his own pattern out of the
butterflies.

And perhaps for this generation whose pride was so
knocked out of it between 1914 and 1919, that is the only
way to work, and they shall inherit the earth.  Perhaps we
readers ask too much and our whole theory of history is
wrong.  Yet I feel that we are right to enjoy when we can
the romantic unities of certain modern historians, and to care
less than we might if we do not always get the chilly and
diffident truth from them.  One can probably say for certain
that all the greatest of the tribe have been and are incredibly
industrious, but this rather difficult quality should be well
hidden in the complete work.  It is certainly one of Anna
Comnena's strongest points, and she reminds us of it rather
often ;  but the art of foot-notes had not been brought to its
Nordic perfection in her day.  It seems a pity ;  she would
have taken so much pride and pleasure in them !

It is doubtful whether anyone really dares to write con-
temporary history now ;  for one thing they cannot get at
the material.  I mean, of course, general history, for certain

aspects of it are being extremely well dealt with by the experts. But the whole thing is too big, too overwhelming ; if some of our writers of romance, bolder than the true historians, attempt it, they seem bound to fail.   Possibly we have even too much respect for posterity and the intelligence of our remoter and eugenic great-grandchildren, to be able to take our courage in both hands and, following the best models, squash down all this mass of accumulated history-stuff into pattern and unity.   And yet very likely it is wrong to think that the historian now should follow any models or prece- dents.   We, like the Byzantines, are living at the end of an epoch, and must beware of rules.

Anna Comnena, both as woman and historian, liked rules.   She tried very hard to follow them ; I believe she knew more or less what a historian ought to be like.   But somehow she did manage to write—as history—a curiously bad history book.   Sometimes one even suspects her of know- ing that—by moments.   Certainly not always, or for the most part ; when she is really in full sail no winds of doubt are allowed to buffet her sideways out of her course ; but at times they did, I think, and show something truer than the elaborate modesties affected by most of the other historians of her century and round about it.   I am afraid she was stupid.   Yet it is just as well to be stupid if one is born into as doomed a civilisation as hers.

In some ways she was sensitive and sympathetic ; she did not like cruelty—none of the earlier Comneni were markedly cruel as the thing went then—and she could see it in many of the customs of her own time, which is more than some of us do.   She was not so stiff as her dresses and simpler than the palaces she lived in.   She was an oldish woman by

the time she started writing, and had probably lost some of her gentleness.   I am sure she was not always the Complete Princess she would like us to think her.   We see her through her own eyes ;  but how different eyes are at twenty and at fifty !

Anna Comnena was certainly a representative woman ; but the thing she represents is dead, and some of this inherent deadness is bound to cling to her and all we know of her. Part of it is the same deadness that may be found by someone in the future clinging to us if we are ever dug up and written about :  the heavy and thick-smelling dust of a long history and a great civilisation, rising about our knees so that we must needs move stiffly and in a well ruled dance if it is not to hamper us too much.   And the other part of what she represents is dead too, because the Byzantines have gone past with little to give us, and even the nestlings of their double eagle are vanished or dying birds now.   But I want to show Anna moving through her dance, a life-time of it, making at least one moderately clear figure partnered and glittering in the grand chain of Byzantine imperialism.

ALEXIUS

THE EMPIRE HAD changed hands extremely often during the last two or three hundred years. We can hardly realise it, accustomed as we are to the comparative calm of West European dynasties. We certainly cannot imagine why any of the capable and intelligent men who schemed and fought, risked death and the most horrible tortures for themselves and their friends just to become Emperors, can possibly have thought it worth while—this precarious throne that almost always brought destruction to the next generation or the one after that, even if they could stay firm themselves ! One feels, and perhaps rightly, that life on the whole must have been rather boring and pointless when all the rich and powerful had no ambition but this, and did so little that was at all original when they got it. But there it was ; the great noble families in their palaces hovered and plotted about the greater palace of the Emperor, fighting his wars with an eye on themselves or their relations. And the Comnenian family, after doing this for some time, at last arrived.

Naturally the Empire was in a bad way. With all this going on in Constantinople and not too much practical loyalty to the State, the farther provinces were gradually disintegrating into one or another kind of barbarism. The Eastern Church had definitely split with the Western ; for

them the supreme clerical power was not the Pope but the
Patriarch of Constantinople.   There was a constant menace
from Russia and all the odd savages from the north and north-
east who still worshipped strange Gods with blood sacrifices
and spoke no decent language.   Among them were the
bands of Varangians, the tall, shag-haired axe fighters ; but
they might be won over with money and the sight of wonders
to serve the Empire and be baptised ; they got the reputation
for better faith than any bodyguard Emperors might find
nearer home.   Further west there were more savages, always
ready to come down out of their hills and plunder.   And
westward·too lay the young Europe, an extremely disobedient
child, constantly sticking pins, if not knives, into its old
mother, and often heretical as well.   South was the sea, full
of pirates, more or less organised and capable of sacking whole
cities.   To the east the real power had left the Arabs and the
old line of Caliphs and had passed to the Seljuqs, a Turkish
tribe which suddenly appeared and for several generations
was terrifically vigorous, a great natural war machine under
extremely able chiefs.   The Seljuq centre of gravity was
further north than the earlier Arab one ; Asia Minor was
one of the first objects of their desire for conquest and rule.
And besides all this, within the bounds of the Empire there
were constant civil wars between one general and another,
each promising himself or his son the purple.

     That was the state of things when the Comnenian family
began to come into power.   They were Greeks, with large
possessions of land both near Constantinople and in Asia
Minor ; probably they came originally from Macedonia.
They must have intermarried a great deal, both with the
other great Greek houses and also, as the custom was, with

foreign princes and princesses, who might bring in almost any sort of Northern, Balkan, or Eastern blood. But probably Constantinople had more mixtures of races and colours in it than any city before or since, and you would be hard put to it to find a pure-bred family of anything after it had been there for a few generations. The earliest of this family to come to the throne, Isaac the First, reigned only two years, from 1057, very efficiently. His two children by a Bulgarian princess died before him ; he was succeeded by a quite worthy but very uninteresting friend of the Ducas house, he in his turn by others, none for very long. It was the custom for the successful Emperor to put out the eyes of the less successful candidates ; if this was done clumsily and the wounds were forcibly neglected afterwards, a peculiarly painful and unpleasant death would result, without any of the awkwardness of a formal execution. Much of the government, in practice, was done by the wives or mothers of the various Emperors.

Isaac I had a brother John, who was either set aside, or did not choose to rule. The brother had first been married to a Bulgarian princess, but after her death to Anna Dalassena, an extremely strong-minded lady, descended on both sides from great houses, who is represented by some historians as protesting vigorously when her husband does not take the crown, accusing him of moderation and philosophy and all sorts of unromantic things, and finally abandoning herself to sorrow when nothing comes of it. They had eight children, with two of whom particularly, Isaac—the eldest after the death of his first brother—and his younger brother Alexius, we have to do.

We have two descriptions of Alexius, one written by his

daughter, the other by his equally devoted son-in-law ; neither
of them is very convincing : the qualities of body and mind
are too much in a pattern.   The chronicler Zonaras, though
he gives a long and quite able account of the Emperor's
character, adds little in the way of convincing detail.   But one
gets some sort of idea.   He seems to have been medium-sized,
but strong, active, and sudden in his movements ;  he was
dark and bright-eyed and adventurous, spoke well and enjoyed
it, though we are told he could never pronounce his Rs.
There are also two illustrations to manuscripts, which show
Alexius, in a plain halo, talking firmly to God in a superior
one.   He is frowning, with deep furrows over and under
his eyes ;  his beard is short and black ;  God looks impressed.
In his young days at least he must have been something of a
charmer, and all the romantic circumstances were with him.
He had started soldiering as a boy, with a natural taste for it,
and as he grew up was sent off on the most difficult cam-
paigns.   Between whiles—and of course these were still the
good old days when wars for the most part were conducted,
properly, in the fine seasons, leaving the armies free to go
home in winter—he lived in Constantinople, and was much
at the Palace.   This partly from necessity of Imperial
councils and ceremonial, partly because if one was at all under
suspicion it was better to come into the open than to hide
among one's friends, and partly because the Empress, Maria
the Alan, was an extremely beautiful creature.   She must
have been brilliantly coloured, with soft and delicious eyes,
and every attraction for a lover that the dress and art of the
time could give her.   She was not so much older than he,
though twice married, first to one Emperor, and then to
another who was proving as unsatisfactory a husband to her

as he was governor to the Empire.   The Empress probably
thought there was something to be said for marrying a third,
who seemed likely to be better in both capacities.

One obstacle to this was that Alexius was already married,
to Irene Ducas, the fifteen-year-old daughter of one of the
greatest of the rival houses.   Her father, Andronicus Ducas,
was dead, but she had a most efficient grandfather who looked
well after the family interests and had married her to the
perhaps rather reluctant young general.   It is a little difficult
to get a very good picture of her at fifteen ; she 'joined to an
admirable beauty an extreme purity of manners ' and her
daughter says all sorts of nice things about her : a mixture of
sweetness and majesty, a hand and arm of marvellous white-
ness, eyes like a calm sea, a Queen such as one imagines
Pallas Athene, growing like a young plant—there it all is,
nice but quite unconvincing.   Well, let us grant Irene her
aristocratic beauty, but even in the description there is some
slight chill : Alexius, widower already, perhaps half in love
with the Empress Maria, was scarcely full of devastating
passion for this stiff, half-grown girl.   There were no
children yet, and something might always be done with the
Patriarch of Constantinople about the marriage.

Maria herself had a young son, Constantine, by the first
of the Emperors to whom she had been married : a delicious
and romantic child, as one sees him through Anna's eyes a
whole life-time later : all white and rose with golden hair
and eyes bright as a falcon, a beauty that made everyone love
him.   In theory he was the rightful heir to the Empire,
assuming that Maria's second husband, the Emperor Botani-
ates, was a simple usurper—as he certainly was !   But in
those stormy times one needed to be a strong man before

one's claims as heir could be accepted. There was no
chance, unless some very exceptional mother or uncle man-
aged to keep the real power, for any

> Baby face with violets there,
> Violets instead of laurel in the hair,
> As those were all the little locks could bear.

However, Alexius promised, if he got the throne, to
make the child Constantine Cæsar, with all the dignities and
trappings of that great name and office ; that was fair enough
and all Maria his mother could ask, for this assumed him to
be heir to the Empire.

The two Comneni, Isaac and Alexius, were obviously
much the most capable, and, up to a point, the most loyal,
of the Emperor's Generals.   But the inevitable revolution
happened ;  it was started by the jealousy of two of the
Emperor's favourites, who advised him to do the usual thing
and put out the eyes of these too promising young men.
They fled from the city, as the song said :

> All on a Sunday,
> Like lively, light falcons,
> Out of the net !

Their mother, Anna Dalassena, and the rest of the
women, took sanctuary at Saint Sophia's and required the
most binding pledges from the Emperor Botaniates before they
would come out.   In a very short time the brothers had an
army, a quantity of followers and rivals, mostly relations, and
sufficient money for their purposes.   They marched on Con-
stantinople, which fell into their hands, after the expected
treachery by part of the Imperial Guard, and some excite-

ment about the fleet.   There seems to have been little blood-
shed, but a lot of pillaging ; however, the inhabitants were
presumably prepared for that ;  the churches suffered perhaps
most, but could probably best afford it.   The Emperor, an
oldish man, deciding that it was no use holding out, retired
with moderate grace into a monastery ;  his eyes were not
put out, so he might think himself fortunate.   It is unlikely
that he was made to practise any great austerities—very few
monasteries were like that ;  they were more like a superior
and condensed suburb to which one retired at the end of
one's business life.

The question now was whether Alexius would be able
to carry his next point and marry the Empress Maria, as he
undoubtedly wished to do.   His mother, who disliked the
Ducas family and her uninteresting little daughter-in-law,
would have helped him.   But the Ducas grandfather and
the Patriarch of Constantinople stood firm.   The fifteen-
year-old Irene was crowned seven days after her husband,
and poor Maria was persuaded to leave the Palace.

Alexius had got the better of his various rivals for the
purple through sheer merit ;  his elder brother had recognised
it at once and had insisted on being passed over ;  agreements
had been come to with the other claimants.   And it was as
well for the Empire that this was so.   There were enemies
on him at once, and the first thing he had to do was to
reorganise the army and fleet.   As always there were the
Turks, but still worse the Latins were up against him on the
west.   They were led by Robert Guiscard of Normandy
and Northern Italy, the villain in chief of Anna Comnena's
history, whom she is never tired of describing with more and
more delighted horror.   She is a good classicist, and Robert

had all the romantic virtues and brutalities.   He was a blonde
beast, a rather Homeric adventurer from Normandy, wanting
all the obvious things out of life :  battles and money and
power.   The most obvious thing of all to want was the
throne of the Empire, with all its staggering, half-magic
associations of richness and splendour.   The only claim he
had was that his daughter Helen was betrothed to the boy-
Cæsar, Constantine.   It is an unhappy little story.   The
betrothal had taken place in the days of Constantine's weak
and foolish father, Michael VII—two Emperors ago.   The
Greek prince had been a baby, the barbarian princess little
older, but she had been packed off to Constantinople, and
there she stayed.   We have no sort of picture of her ;  Anna
says with a grim conciseness that she was unhappy because
of the extreme aversion Constantine had for her.   They
were both children then ;  was it that he wouldn't play with
her, found her clumsy and tearful perhaps ?   Or had they
been forced into a half-grownupness that showed itself this
way ?   Anyhow, her father found her a sufficiently good
excuse for attacking the Empire.

Alexius had used all his money on the revolution that had
brought him the throne ;  he had hardly any soldiers ;  every-
thing was in confusion.   He rose to it at once, showing the
peculiar Comnenian genius for strategy and making the best
of a bad job.   He wrote to Henry IV of Germany, got
hold of various other Norman lords and induced them to
make war on Robert, tried to make a treaty with the Pope,
succeeded in making one with Venice which gave him their
fleet as a most valuable ally, and finally and most important
made peace with the Turks and got himself in that way a
free hand to concentrate on his western frontier.

In the meantime Robert and his son Bohemond had crossed over from Italy and were besieging Durazzo ; the Emperor weñt there himself with the army he had managed to raise.  After some skirmishing he was beaten and Robert took possession of Durazzo, which gave him command of all Illyria.  A little time afterwards Robert was forced to go back to Italy to put a stop to the revolts there—mostly the work, one way and another, of Alexius—and Bohemond took over his armies.

This Bohemond came a great deal into Anna's life and history.  For her, he was the typical barbarian, more powerful even than his father.  He stands for the antithesis of all her standards, and in a way she sees this and respects it.  But during this first campaign, which takes up more than two books of the fifteen in her Alexiad, she herself was yet unborn, and it will be better to leave the description of Bohemond until the time when they meet.  He was still quite young when he took command of his father's men : French or Latins, either name does : and he showed himself a born leader, brave and skilful and full of cunning.

All through his life the Emperor Alexius kept on losing battles, yet somehow making good.  The losses were the fault of his lack of men and materials, seldom due to any fault of his own judgment or military skill.  He escaped the consequences time and again with amazing brilliance of stratagem or diplomacy, and this was all to his credit.  But it was unfortunate material for his biographer.  Poor Anna was so happy in describing her father's rather few victories ! She must have found it trying to have to write so often about honourable retreats.

However, they sometimes produced at least an exciting
story of the Emperor at hazard with tremendous odds,
escaping from the very hands of his enemies. After his
defeat by Robert, for instance, there is a thrilling description
of his flight, pursued by the French, along a narrow path
between torrent and mountain, called Wicked Way by the
country people. Nine of the foremost had caught up with
him ; he was struck with lances on the left side and would
have been thrown but that his long sword caught in the
rocks and held him up. But his left spur got tangled in the
stirrup—all he could do for a moment was to hang on by
his horse's mane. Then by an extraordinary piece of luck
some wild attacker caught him on the right side with a lance
so violently that he was shoved up, armour and all, into the
saddle again, and could use his own lance and sword. Yet
ahead of him Wicked Way was still full of the shouting
barbarians. Alone, they must have ended him. But then
Bay-brown, that best of horses, reared up and with one great
clattering bound was on to the hill-side above them. One
moment the war-horse was high on the crest of the rocks,
knocking the lances sideways in mid air, the next he was off
and up the path again. Just once the Emperor turned for a
lance thrust at one pursuer who had caught up with him
again, then the rocks hid him. But all at once, in another
turn of the path, he came on a second band of French, who
stood together with ranks closed, resolute to take him prisoner.
In despair Alexius caught sight of a man in the middle, hero-
size and wearing splendid arms, and, thinking it must be
Robert himself, the arch enemy, charged him. They rushed
together, but Alexius got his lance point in first and threw
the Frenchman. At that the others all broke ranks and

c

rushed towards their wounded leader, and Alexius burst
through them and was saved !

One can imagine him telling all this to the children ten
years later, little Anna so thrilled to the marrow that she
remembered it all her life and had it clear in her head as an
old woman. The kind of thing that makes even defeat
enjoyable to write about !

But after this Alexius found it absolutely necessary to
raise money and a fresh army ; he went back to Constanti-
nople, leaving the Normans to continue their conquests, and
set about looking for what he needed in all haste. His own
friends and relations gave all they could, and he raised funds
by rather violent taxation, ' quite removed from all reason
and mercy,' Zonaras says : and also did some juggling with
the values of the coinage, paying in one and receiving in
another. But all the same it soon became essential to lay
hands on church money. It was done as decently as possible,
but there were inevitable disturbances, and the old question
of image-worshipping came up again. Somehow it was
always possible to find bishops and monks in the Eastern
Church ready to flare up into words and even deeds, and
flout an Emperor himself. Alexius was on the whole
wonderfully patient with them ; he would have made a good
theological controversialist himself if his life had lain that
way ; but there were a few banishments.

He raised the money, gave back pay to his mercenaries,
and enlisted many more from all over the Empire ; he saw
to their training himself, and by-and-bye they were fit to
take the field against Bohemond and the Latins. They were
not altogether successful at first, though Alexius did his best
with dazzling offers to the French and Norman counts who

were serving under Bohemond. But finally, with the bought help of the Venetian fleet, he got the better of the French army, and was able to return for a time to Constantinople, where there was plenty for him to do and think about. Not only the affairs of Church and State, wonderfully tangled and complicated, revivals of heresy, plottings and murmurs ; but also the Empress, his young wife, just going to have a baby and already installed in the porphyry-lined room where such imperial events always took place—that polished reddish-purple, a trying colour to gaze at for a woman in the middle of her pains.

This stiff little Irene Ducas was beginning to get the power which was going to be hers, though perhaps she scarcely felt it yet. No doubt those first three years of marriage had been difficult enough. Alexius, with his determined old mother well in domestic control, was not the type of Emperor to have Imperial Orgies in the style of some of his predecessors ; most likely he and his old love Maria the Alan scarcely met again. But that cannot have made him any more in love with Irene. Obviously there was no sort of cunning and delicious frivolity about her, none of the arts which are thought to attract reluctant husbands. She liked books and church and good works—she even read at meals ! Perhaps her first real contacts with Alexius were over points of dogma. There seems to have been very little idea in those days of any intellectual inferiority of women, and Alexius may have learnt to respect her over theology.

At the end of her nine months the Emperor was not yet back in the capital, though expected every day ; her first light pains began. She made the sign of the cross over herself, saying : ' Little baby, wait for your father ! ' Her

mother who was there spoke angrily : ' He may be another
month ! ' and must have thought : The little fool, not know-
ing what it will be like before the end ! Alexius was another
three days, and Irene, poor thing, must certainly have regretted
the gesture. But at the end of the three days a baby girl was
born.

# 3

## CONSTANTINE

ANNA COMNENA was a Saturday child—Saturday, December 2nd, 1083. There were fantastic rejoicings, with terrific ceremonial of Church and State, baptism, reception of notables or their wives by the mother in her imperial lying-in bed, and the diadem for a moment laid on the forehead of the tiny, pink, wrinkled princess as she was, perhaps, shown from a balcony to the shouting people of the Empire. After that no doubt wet-nursing by noble ladies, and an embroidered and jewelled robe over the linen swaddling clothes, and a cloth of gold-covered stiff pillow to carry her on and give her a straight back. A whole bevy of nurses with a grandmother to supervise them for little Anna, while Alexius and Irene prepare to do their Imperial duty and produce another prince or princess.

The baby Anna's name was now always put immediately after Constantine Cæsar's in official proclamations and so on. From this it was an easy and obvious step to betroth the two, and Anna went to live with her future mother-in-law, the still lovely Maria, in her own palace, which was quite close to the Imperial one, so that she was never far from her parents, or later on her younger brothers and sisters. In some ways it must have been a curious emotional atmosphere for a little girl in those most impressionable first eight years of life. No

37

doubt she only half understood what had happened to this beautiful almost-mother whom she so loved ; she could not quite see the nature of the pain, the unsatisfied love for the father perhaps shown in passionate, violent tenderness for the child by his other woman.    Yet, if one has been brought up among these tense murmurings of old wrongs and long- ings, most of all when they are associated with loveliness and kindness, one gets a romantic attitude to life, and one's own self becomes coloured with other wrongs, real or imaginary but sprung ultimately from these.

Probably Maria's palace was a pleasanter, perhaps even more light-hearted place than the Imperial palace, governed as it was by the Arch-grandmother, Anna Dalassena, who had been actually regent during some of her son Alexius' long absences, and who had the severest possible ideas about everything, in the State and the family alike.    She had made short work of the somewhat unbounded liberties of enjoy- ment under the old palace regime, and everyone had to be in time for both prayers and meals.    Visitors, other than busi- ness or ecclesiastical, would be discouraged ; there would probably be no frivolling with the arts unless they had been strictly domesticated or put to pious uses.    She was never popular and certainly did not want to be ; she liked and got respect and much power for a time.    Her grand-daughter's chapter devoted to her and her good works is not tinged by any undue affection.    But the other palace must have kept more of the romance, if not the manners, of old days ; here surely was still the softness, the gold and colours and the sweet smells, the wild sobbing of music in tune with lost loves, that vivider barbarian strain still perhaps alive in the Empress after all her years among Greeks and churches in Constantinople.

In her own history Anna Comnena looks back at all this through a long veiling of years ; childhood is never clear, always full of mysterious moments of unexplained excitement ; and how much more hers that included the husband-to-be, Constantine, that delicate, half-real figure, who becomes more and more the fairy prince of her imagination when later on she grew old in a hard material world of solid fact that she could not ever hope to colour to her liking. One knows how a little girl can adore a big boy with a somehow sweeter and less reserved generosity than anything poor grown-ups can have between them ; mostly perhaps because it is not caught up with reservations and modesties, all the shame and stupidity of sex. Here it was made perfect because there was no grim gulf of school and separation to imagine, but one day the greatest Throne in the world to share between them, all the treasures to play with, armies to order about, the Court like a great coloured glittering toy to wind up and make go, churches and palaces to build, whole new towns to found !   And always together Anna and Constantine were to live happily ever after.

He was ten years older than she was ; towards the end there might have been some very fine and delicate love-making, enough for wonder rather than excitement.   And while they played, to the tune of Lavender's Blue, what happened to poor barbarian Helen, Constantine's first betrothed ?   She was older than either of them and probably the play instinct had long been driven out of her ; perhaps there were one or two old Norman nurses who sang her songs and told her stories in some upper room of the palace looking towards the north.   Her father had died of fever in her mother's arms, on his way to a great attack on the Empire ;

her brothers took up the quarrel just as formidably for a time, but disturbances in Italy brought them away again fairly soon and left Alexius in momentary peace. But by now Helen must have felt herself too far from home and help to care much what happened to any of her family.

Another princess was born as soon as possible after Anna; she was named Maria, and later on the two sisters were devoted to one another. But after her in 1088, a brother, John, at last appeared, to be met with even wilder rejoicings and a greater assurance of power for the Empress Irene. Anna makes him an unattractive but plausible baby with a big forehead and small face, black eyes and a sallow skin, a baby with a temper who perhaps didn't like being played with by a five-year-old sister. No wonder she didn't like him; he meant—and she must have known it from nurses, if not from Maria and Constantine themselves—the end of her fairy tale. She and her best friend were not after all ever to be Emperor and Empress; the throne would go to John. Maria did her best for them, protested, fought for her son, but all that came of it was that she had to leave her palace and go to a convent. Anna went home again to much love and a solider education—with perhaps more discipline—but no longer to be the one and only darling. Her prince came with her too to the court and perhaps that made it less hard; in spite of his mother no one could hate Constantine; he had all the loveliness, the fleeting grace, of a Greek boy out of the Golden Age. He seems to have been really fond of Alexius and grateful to him; but for him he would have had no position at all and perhaps he did not care so much to be Emperor as his mother did for him; he may have found her

embarrassing—most likely she demanded too much both in affection and in ambition from her only son.

Anna was given the best education of her time ; as far as that went there was no idea of putting women in their place in those days. She is proud of it too and describes it more than once : ' languages, and mostly Greek '—what other tongue except Vergilian (not spoken) Latin would not have been despised ?—' all the sciences, all the arts, mathematics and the philosophy of Aristotle and Plato.' This would have included reading the best ancient authors : those at least which the Eastern Church approved, and it was probably most broad-minded outside its own dogmas ; one must remember that all professorial posts were held by church-men and that it was regarded as a profession rather than a vocation. Perhaps this came partly through its being still the Roman Empire, where once the Pontifex Maximus was a politician going through his regular career. The clergy of Constantinople were for the most part politically-minded, though here and there monks of immense piety and asperity appeared and refused to be run by either side.

Homer was the ancient author most read. He was regarded by educated people as something between the Bible and Shakespeare. Anna must have known many hundreds of lines by heart, and quotations from the Iliad and Odyssey are scattered thickly and aptly through her own book. She took in Homer very much better than either Plato or Aristotle. Obviously a great deal of her style is deliberately modelled on her great example, and the many formal descriptions of two armies or two commanders on opposite sides seem to try and recall Homeric single combats ; God looks on, as though from Olympus. But there is little Platonic romance

and not much more Aristotelean moderation ; one feels she
was more likely to be interested in the practical Aristotle
whose natural history was no worse than hers. But I
expect she liked the later Stoics best. Education in the poets
meant quite a remarkable amount of parsing and analysis,
picking out and framing of metaphors, a continuous com-
mentary by a generation which produced no poetry of its own.

It is interesting to see how later on Anna herself com-
plains of the methods of education then fashionable, demand-
ing something more humane and less formal. It is all very
sensible, and she regrets the time she herself spent in playing,
as it were knuckle-bones, with mere verbal exercises, while
the real stuff of literature was neglected. Almost anything
could be made a theme for these curious exercises ; they were
composed entirely to schedule, and must have been fun for
an intelligent, half-grown child in the same way that the
formalities of modern education are sometimes—or, perhaps,
were, for now every year sees less and less of Latin verses
and such-like charming jig-saws.

Ancient history would have come into Anna's curriculum
too, though she does occasionally go wrong in her references,
as when she gets Alkibiades and Themistokles rather badly
muddled. She got the habit of classical names and perhaps
thought of the more outlying parts of her father's Empire in
too Herodotean a manner. Her Scythians seem copied from
books rather than from nature, though one must not stress
this too much, for many of their curious and bloody customs
—the burial of chiefs with their best horses and perhaps a
slave or two, and the blood-brothership rite—were much as
they had been more than a thousand years ago, though the
people who practised them were not even the remote descend-

ants of the ancient Scythians, but were a quite different stock, successors to their successors. Anna always feels called upon to apologise for the barbarian names she must needs bring in from time to time, not only for the various ' Scythians ' and such, but also for the Crusaders when they came, Godfreys and Tancreds who did not make up at all nicely as Greek words.

Many things that were going later on to be science had not yet split off from the bulk of philosophy. Much of the mathematics was there still, besides astronomy and such physics and biology as was known to the Christian world. Geography was more of a science, though Anna's must inevitably have been inaccurate beyond a certain distance from the Capital. We hear nothing of any crafts, nor, really, of any arts in her education.

There would also have been much theology, including careful reading of both the Old and the New Testament, and probably a great deal of formal logic, to be put to the uses either of theology or philosophy. Very likely as quite a child Anna would have sat and listened to the come and go of this type of ceremonial argument. First perhaps among the women, for her mother and grandmother would both have practised it, sitting in high stiff chairs with their hands folded in their laps and their ladies beside them to murmur applause at the points ; and later when her father in full court, robed and crowned, argued with heretic professors or generals, and his eyes shone and the periods of set rhetoric came spinning out of his mouth. Psellos had lately filled the principal Chair of Philosophy at Constantinople and had left a rather Jowett tradition behind him ; his successors were apt to be thought too modern and violent. Sometimes Pagan beliefs and fables

crept in through the Classics and had to be sat on.  It was important to keep the language and grammar as pure as possible, though they were already far from Attic : the official speech full of imported Latin words and constructions, that of the people hopelessly collapsed and degraded.

There seem to have been no plays of any sort ; respect for the Classics did not go that far.  The kind of shows that happened in the Hippodrome were classic in the Derby sense, and the Emperor attended officially, but they were not educative.  Probably there was a good deal of church music and some domestic, but Anna never speaks of it.  I doubt if she was musical or cared at all about painting, though sometimes she invokes the shades of Apelles—had anything of his survived up to her time, or was he the mere name he is to us ? —in describing someone.  Some goodish work was being done in the Empire at this time, mostly carving, mosaic and metal work, inlay and such ; it is curious how almost always there is a convention of squashed, dumpy figures, as though the weight of the centuries had fallen even on the heads of the apostles.

Anna was much more scientifically minded than either of her parents and did not share her mother's taste for reading the lives of Saints.  The doctors of the Church seem to have frightened her rather, though, as we see later, she was always much interested in natural phenomena, liking a nice tidy explanation, and in any sort of technical achievements of peace or war that came her way.  She learnt a certain amount of medicine, for that would all count as part of any young lady's domestic training, and she probably had some idea of household crafts.

The difficulty about it all was that everywhere, in every

sort of learning, there was too much criticism of things long done or written, old bones gnawed over and over and never yielding any marrow because they were never attacked from a new side or in the light of new theories. There was no fresh creation ; the impulse to it was so discouraged. It must have been amazingly bad for everyone, because after all education should be a matter of drawing out, not of learning to obey exquisitely complicated sets of rules.

Constantine probably learnt to ride and hunt and shoot, and the theory if not the practice of war, almost as formally. All the children of the Court would be bound to get by heart the whole fantastic ceremonial of every day as it had to be lived by the great. Any Court is ridiculous enough with its changing of clothes and posturing and walking backwards and avoidance of certain forms of truth, even if the more profound and respectful prostrations have degenerated for us to a mere curtsey (but with the eyes suitably cast down and the smile well in control) and our skirts not too short and our necks not too low (nor too high) for the Lord Chamberlain. But the Byzantine Court carried all that to its most elaborate, took every possible scrap of life out of the dolls on the Throne, made them as nearly ikons as possible. When one comes to consider it all, one is filled with admiration to think that they ever came sufficiently alive between times to win battles or beget children, still more to think.

Alexius had very little peace from his enemies. After the death of the great Seljuq ruler Sulaiman, there was a general scramble for possessions in Asia Minor and continual wars and negotiations and treaties between the Greeks and one or another Mohammedan emir or general. On the whole things went not too badly there, particularly after the

death of Malik Shah, the other great Seljuq of the Eastern
house. Anna always speaks of the Turks as comparatively
civilised enemies : after the Normans at least !

On the Danube frontier war broke out ; here the enemy
were partly the wild Patzinak tribes and partly Manichean
mutineers from the Imperial army. First the Emperor won,
then he was defeated ; then, fortunately for him, the savages
began to fight one another, Patzinaks and Cumans. It was
finally with the help of the Cumans that the Emperor man-
aged to defeat his original enemies and freed the Empire for
a time from the hordes that were always roaming round its
edge.

It was in 1091 that this happened, and he was able to
stay at home in Constantinople for some time and put his
own house in order. One watches him quite gradually get-
ting more and more power into his own hands, gently taking
it away from his mother, Anna Dalassena, urging her nearer
and nearer to the convent into which she finally retreated,
still up to her very old age to have long theological arguments
and browbeat the nuns. Yet, as she lost power, so little by
little the patient Irene got more ; it may have been that the
Emperor was in the habit of consulting a woman and did not
quite realise that, failing his mother, it must be someone else.
At any rate he became accustomed to his wife ; as he grew
older and began to suffer from what Anna calls the gout—it
sounds sometimes like violent rheumatism, sometimes like
asthma, sometimes like a gradual hardening of the arteries—
so he found he needed Irene more and more to look after
him. And it was a vague line between nurse and counsellor.

Gradually, too, his eldest son John came more and more
into the father's thought. He was fond enough of Con-

stantine and reasonably fond of justice, but soon it was quite clear to everyone that John was to take Constantine's place entirely. Anna's fairy prince seems to have shown no marked ability for governing ; his father had been a poor creature. John had at least the advantage of the Comnenian heredity. After the victory over the Patzinaks Alexius felt himself strong enough to take the final step ; the next year, 1092, John was recognised as heir to the throne instead of Constantine.

Anna was nine years old, quick and intelligent, half grown-up already ; she saw quite plainly that this was the end of all her plans, that she would never now get as much power as she wanted. It settled her mind into two permanent ideas, first jealousy, later turning into hatred, of her brother, and then the feeling that she was a wronged woman ; this way all her life was coloured ; she could never forget.

It seems sometimes as if every slight that was put upon her Constantine rebounded more strongly on to her ; as each privilege was taken away, down to the last—the most symbolic of all—the typically Byzantine purple boots, it was she who felt it most keenly. The young man himself—he was nearly twenty now—seems to have been contented enough to live either on his great estates up in Thessalonica on the Struma, or else at Court where he had plenty of friends and could see his Anna growing up in grace and intelligence, dark and pretty and keen-witted. In a few years they would marry and perhaps forget all the ambitions they had talked over together as children in another sort of happiness.

In the meantime Alexius had been putting himself right with the Church, which had never quite forgiven him for having confiscated some of its moneys at the time of the wars

with Robert and the Normans.   It was generally thought—
and perhaps Alexius himself shared the popular point of view
to some extent—that his rather constant defeats came of the
sacrilege which he had committed.   However, he solemnly
forbade any of his successors ever to do such a thing again,
and gradually the Church calmed down.

   There were also from time to time conspiracies, sometimes
by members of the family, sometimes by outside enemies of
the Empire who thought, perhaps rightly, that the assassina-
tion of Alexius would throw everything into confusion and
give them their chance.   It was all very trying for the
Emperor, though no doubt not worse than he might expect
on old precedents ; some at least of the conspirators would
usually be caught and blinded.   By now several more of the
Imperial children had most likely been born.   There were
to be seven altogether, three princesses besides Anna, two
princes besides John.   Much thought was certainly given
both to their education and to their ultimate marriages which
could not start being arranged too soon.

   It was not long before the Emperor had more trouble
on his frontiers, this time with Bolkan, the chief of the Serbs.
This very capable rebel had defeated the Emperor's nephew
who was not experienced at this kind of war, and Alexius
himself had to take the field against him.   On the way he
passed close to Constantine's estate, and accepted his hospi-
tality for a few nights while waiting for the rest of his army.
It was a lovely place with fountains and baths and beautiful
buildings ; Constantine begged him to stay on and rest and
bathe for a little time longer, so he, and probably Irene with
him, did so.   But Constantine's uncle, Nicephorus Diogenes,
had followed the Emperor.   This was a man of all the talents,

quick and subtle-minded, a lion in a wolf's skin, whose one constant ambition was to seize the throne to which he thought himself entitled as brother of the Emperor Michael Ducas—two reigns ago—first husband of the Empress Maria and father of Constantine. He was the leader of perhaps the most serious conspiracy that Alexius ever had to deal with, and he was impatient to get it over ; already he had missed one chance of assassinating the Emperor. Constantine must have known he was there, but it seems most likely that he knew nothing of his uncle's intentions ; he was not the kind that conspirators choose to tell their secrets to.

One day as the Emperor was coming out of his bath, Diogenes came in with a drawn dagger ; but for the courage and faithfulness of one of the generals that would have been the end of Alexius. But the conspiracy was betrayed now ; Diogenes' first thought was to escape to the Empress Maria, his sister-in-law. She must have known about it all, but Anna loyally says she had tried to stop it. He had to have a horse and asked Constantine to give him the one that had only just come—a present from the Emperor ; but Constantine, embarrassed or shocked, refused. Before he had time to make any other plan Diogenes was arrested, questioned for a day and a night, then put to the torture. His confession brought in all kinds of friends and relations of the Emperor's ; it was all terribly puzzling. But Constantine seems to have been innocent ; he was bidden to stay at home in his beautiful house, since he was still young for war.

It ended with exiles and confiscations ; Diogenes had his eyes put out ; yet perhaps that was less than he would have got from most Emperors. After a time some of his moneys were given back to him, and he went to live in the country

D

and study music and solid geometry.    After that for a while
there were no more conspiracies.

As for the lovely Maria, her convent became more and
more of a prison.    She does not come any more into Anna's
history after that year ; she must have died soon.    And Con-
stantine perhaps came to Court less.    Innocent or not—and
only the Emperor, who had himself questioned all the accused,
knew that for certain—he must have been under suspicion ;
Anna would have seen little of him for the next year or so.
All this happened in 1094 ;  before 1096, at least, the fairy
prince was dead of a fever.    We know no more ; Anna does
not tell us ;  after all, she was writing her father's history,
not her own.

## 4

BRYENNIUS

ANNA RECOVERED. After all, at twelve years old a
shattered romance is reparable. No doubt everyone was
kind ; and the processes of her own body and mind growing
were distraction enough. In another year or less a second
romance was put in her way, under the unpromising shape of
a *mariage de convenance*.

The more we see of ordinary ' love ' marriages, the more
we incline in favour of the *mariage de convenance*, though
perhaps this would not be so if we lived in a country or social
class in which the latter is the more usual form. Naturally
there was little else among the noble families of Constanti-
nople, or in fact of Europe at that epoch. It was nothing
for a sovereign, looking for an alliance more solid than mere
oaths could make it, to arrange a marriage between, say, a
ten-year-old son and the daughter four times his age of another
potentate. Or again, there were the inevitably unhappy
betrothals between East and West, as poor Helen's. Here
she was now, left in a miserable and despised half-widow-
hood ; one can only hope she had some lover faithful and
kind enough to comfort her, and that perhaps one's pity is
wasted. At any rate the marriage arranged for Anna
Comnena was not really at all fantastic.

The first Nicephorus Bryennius had been another of the

51

generals who had revolted and made a bid for the Throne.
Actually it had been Alexius who, then loyal, was sent out
against him and took him prisoner ; it was not until after-
wards, when he was taken before the Emperor, that his eyes
were put out.   A later historian accuses Alexius of the order,
but it seems unlikely, both in regard to what one knows of
Alexius, and when one considers that old Bryennius seems
to have borne him no malice after he became Emperor, but
rather to have done all he could to help forward the marriage
between his son and the eldest of the princesses.   He must
have been a nice father-in-law by the way Anna always writes
of him, perhaps even inclined at first to sentimentalise over
his son's little wife.

This son was another Nicephorus Bryennius.   He died
before Anna and she cannot bear to write his name without
tears.   Sometimes it seems that she cannot even stand think-
ing of him as her own loss : it was the State, she cries, the
State who lost such a Prince, so wise and experienced, so
great-hearted, so rarely full of goodness, so splendidly worthy
of every honour, such a man !   Anna exaggerates as usual.
But he must have been nice.   Obviously he was a capable
soldier, brave, sensible, moderate, an influence for good in
any council, but not ambitious : an excellent second-rate
always.   Alexius knew this from the beginning, his daughter
almost never :  Bryennius himself—perhaps.   He wrote
worse history than Anna, but it is quite conceivable that she
thought it better.   At any rate he himself was very modest
about it, saying in his introduction : ' I am only writing
memoirs, subject and matter for a history.'   And that
modesty was probably quite genuine.   As far as one can see
he shared all his wife's affections, though less violently.   In

spite of the treatment given to his father, nothing had man-
aged to give a permanent twist to his childhood or set him to
fight the march of events ; here at least he was different
from his wife.

He must have been older than Constantine, thirty per-
haps ; one feels sure he was kind and understanding.  Irene
thought him the perfect son-in-law, and Alexius, aware of
his limitations, trusted and favoured him.  Anna finished
her growing up after her marriage and probably much in-
fluenced by him ; but he never changed her at bottom,
though I am certain she did her hair the way he liked it.

They were perhaps married in a moment of more or less
peace for the Empire, but before many months, before the
end of 1096, there was something stronger and more alarming
than Turks or Patzinaks coming down on the Byzantines.
This was the First Crusade.  These earliest Crusaders were
the barbarians against whom Anna, just in the first flush of
her new romance, had to arm and send out her knight.

During his early troubles Alexius had certainly asked for
help in the West.  He smoothed down the relations between
the two Churches and had some correspondence with the
Pope, Urban II, who had succeeded the greater Gregory,
with the short reign of unfortunate Victor III between
them.  During the war with the Patzinaks, Alexius had
asked him to raise and send him a body of mercenaries, and
he had asked the same thing of Robert of Flanders.  But the
last thing he wanted or asked for was half Europe flung at
his head in a wild Crusade, even though their avowed enemy
was his enemy too.  Allies and enemies are so dreadfully apt
to get muddled up in the stress of the moment.  The
Emperor has been accused by all the Western chroniclers of

perfidy, of begging for help and then turning on his helpers,
betraying them to the infidel. This seems now to be quite
disproved, though we are still left with the fact that the moral
ideas of the two forces, the old Empire and the new Chivalry,
were very different, and we are inclined to prefer our own
ancestors, the armies of the West.

The great wave of crusading enthusiasm swept over all
Europe within the space of a few months. It was a real
enough thing, this sudden turning of the spirit of war towards
the deliverance from the heathen of Christ's tomb and City.
It was a spiritual, a mystic impulse, for Kelts and Nordics,
the enthusiastic and woolly-minded of this world. The
practical Byzantines, still based on all the solidity and un-
imaginativeness of Rome, did not understand in the least.
Peter the Hermit, infinitely noble, ascetic, charitable, exalted
in mind, saint of the West who heard Christ's voice and could
not rest afterwards—he looks quite different in Constanti-
nople. Anna says : ' A certain Frenchman called Peter the
Hermit, having been to Asia to adore the Saviour's tomb, and
having been ill-treated there by the barbarous Turks and
Saracens who ravage that country, came back very badly satis-
fied and resolved to make his second journey better than the
first. He thought he would succeed better in this design if,
instead of going by himself, he went in good company ; so he
declared that God had commanded him to go and preach to
the Counts of France, bidding them go and adore the Sepul-
chre and deliver Jerusalem from the tyranny of the infidels.'
And that was that. Nor is she much more sympathetic with
any of the other leaders of the First Crusade, though she seems
a little sorry for the rank and file, as well she may be, for it
was they who were the truly religious and they who had most

of the suffering and trouble and astonishment at a reality so dreadfully different from their dreams.

Urban II preached one crusade and Peter the Hermit another ; his word went perhaps more to the poor and oppressed, the peasants and farmers who left behind all they had and started off, whole families together, for a Jerusalem that they could not imagine further than beyond the next range of mountains. The knights from the little castles followed him too, and the poor squires who must groom their own horses, and the students not yet tonsured. They started before the great barons had finished making their arrangements ; most of them came straight through Hungary and burst out of that northern frontier on to Imperial territory.

A swarm of locusts went in front of them, eating the vines and sparing the corn, which gave rise to several interpretations. But Anna is very superior about any superstitions except her own. At any rate these bands of Crusaders, mostly French, had come without any sort of adequate provisions, trusting in Providence, and so were bound to live on the country they passed through. Probably they saw little difference between Greeks and Turks ; both spoke a foreign language and had unfamiliar and therefore wicked customs. So they pillaged wherever they passed, and the knights of the little castles in all innocence killed the Greek farmers who tried to defend their crops and stores.

By the beginning of August, 1096, Peter the Hermit and his ragged armies were near Constantinople. The Emperor advised them to wait for the others as obviously nothing could be done against the Turks until all were united. In the meantime he distributed food and money to the unhappy Latins. But, as they could not settle down and wait but

were still pillaging and fighting just round his capital, Alexius changed his mind and began to have them ferried over into Asia Minor. Here again, they would not stay where they were put, but began attacking the Turks, who turned on them and cut them to pieces on the banks of the Bosphorus. A few escaped in the ships the Emperor sent to help them, and waited wretchedly outside Constantinople for the Western Counts to come. All this was scarcely Alexius' fault, but it did not make them love him any more.

As for the Crusade of the nobles, that took longer to come, and the Empire was more prepared. From the very beginning they seem to have been rather trying. Hugh, brother of Philip I of France, announced himself by letter as 'the King of Kings, the greatest under heaven.' But unfortunately for himself, he was shipwrecked and most of his army was lost with the ships off the Illyrian coast. The Emperor received him with great honour, gave him presents, and 'persuaded' him to take an oath of fealty; he was probably kept as a hostage. The next to come was Godfrey of Bouillon. Things became very difficult; the Emperor's careful diplomacy sometimes over-reached itself. Neither side trusted the other a yard. There was some sort of siege of Constantinople, one scarcely knows how official.

The defence was mostly organised by Nicephorus Bryennius, whose plan was to shoot the horses of the charging knights, on the whole a humane and psychologically sensible piece of tactics. Anna describes him—' my Cæsar '—on the top of a tower among the bravest and skilfullest of the archers, all young, all with splendid weapons, men like the Greeks of Homer. But her Cæsar ' was more like Apollo or Hercules, darting immortal arrows from an immortal bow ; he never

missed his aim and in this far surpassed Teucer and
Ajax.'

Perhaps she could even have seen him like this from some
window of the palace. Here surely was better than the fairy
prince ! And later on, when it was an affair not of war but
of tact and intelligence in dealing with the chiefs of the
Crusaders, she admires him equally ; he combined every good
quality of body and mind, wisdom and eloquence, the arts of
war and peace equally. He had read every book, could
advise on any subject ! He lived up to all the ideals of
Anna's education.

I think that probably Bryennius was as much a repre-
sentative man of his time and social class—the best of it—as
Anna was a representative woman. Even the fact that she
was so ambitious and he hardly at all is typical enough. So
were all the Byzantine women we know, and there are many,
mostly princesses, from Theodora to both the Irenes, to Zoe
or even the charming Sklerena, and, as typical as any, Anna's
own mother-in-law, the Dalassena herself. Too much shut-
ting up in the home, combined with a quite reasonable educa-
tion, had done it. If women are to be kept behind bars it is
silly to compromise about it as the later Byzantines did and
allow them to be intelligent beings at all. It must lead to
discontent and when possible violent ambition. One sees all
her predecessors in Anna ; much of her life stands for them
all.

But her husband had all the remains of the Roman virtues
as they had come down, softened a little and with their corners
knocked off, for a thousand years. He did not question any-
thing in his own time, though he was probably ahead of it in
kindness and good sense. He was deeply interested in

theology, and in this was most typical, for theology played a
much larger part in everyone's life than we can easily realise.
In every generation there must presumably be a few people
to laugh, to keep bright that most powerful sword of ridicule,
but in these days, in the Eastern Empire at least, one knows
literally nothing of them.  Men were either orthodox or
heretics, and there were many heresies to choose from ; but
they always seem to have taken it seriously, as Bryennius,
sturdily orthodox, always did.

With this theology went a curious amount of belief in
portents, horoscopes and predictions.  Anna confesses to
knowing something of the art of drawing horoscopes (as, I
believe, certain great ladies do to this day), ' not so as to know
the future—God preserve me from such a dangerous super-
stition !—but so as to confound the vanity of those who claim
to.'  But of course it is a dreadful thing when people are
encouraged to look up to the heavens for stars rather than for
God.  Her father had the greatest dislike for it all.  But
still—still—there have been a number of curious coinci-
dences, to say the least, which she cannot absolutely put on
one side.  However, it was perfectly right and proper to
consult the will of God in what may seem curious ways to us
hard Northerners.  It seems to have been no very remarkable
thing to lay two tablets with alternative solutions of a problem
on the high altar, to pass the night with prayer and psalms,
and in the morning to pick up whichever came first to the
hand and follow its advice.

But, to return to the invasions of the barbarous Latins ;
they must have been very terrifying, so all the more, when
she wrote about them later on from a safe distance of years,
Anna Comnena let herself go about the Crusaders.  Their

cruelty—the Normans who cut children to pieces and roasted
them ;  their avarice—over and over again ;  their vanity and
insolence—the Count who sat on the Imperial throne itself !
That was our own ' Count Robert of Paris,' in the true
Gothic and romantic manner.   She thinks (and not without
some justification) that many of the leaders were eaten
up with ambition to seize the Empire and simply used the
Crusades as an excuse for this, deluding their poor honest
soldiers all the time.   Even the priests with the Latin armies
do not escape her pen.   ' They do not, like ours, observe the
canons of the Church or Precepts of the Gospel, which forbid
them to draw the sword and smite . . . They are men of
blood, breathing out murder. . . . While ours, on the
contrary, are faithful imitators of the gentleness of Aaron
and Moses. . . .'

There was one priest in particular, who was so warlike
that he went on fighting after the end of the battle, intent on
his single combat with the Greek general Marien Mauro-
catalon, and, having shot away all his arrows, threw such a
huge stone that it broke the General's shield into four pieces
and knocked him to the ground half dead.   But he, coming
to himself, got up and wounded the priest three times.   He,
not able to find any more stones, shook with rage like a wild
beast, and finally threw a sack of bread at his enemy !   The
end of it all was that when the fighting was all over, the
priest asked everyone to bring him to the General, and, having
found him at last, kissed him delightedly, gave him a golden
jar worth three hundred staters, and then suddenly died !   No
wonder East and West could not manage to understand one
another.

Bohemond the son of Robert Guiscard, the old enemy,

was the next to come.  He brought his nephew Tancred,
even more wild and farouche than himself.  His idea, at
first, at any rate, was to use the Greeks to help him to a new
kingdom, vaster than the Italian territories his father had left
him.  He took the oath of fealty and asked to be made Grand
Domestic of the East, but was put off with promises and
presents for the moment.  It seems quite likely that during
his stay in the capital he should have made friends with the
Emperor's son-in-law, the sensible and moderate Bryennius,
who would have understood the importance of keeping him
in a good humour and perhaps did some of the showing round
which always impressed these barbarians so much.

Constantinople was full of wonders.  There were
jewelled trees with singing birds of gold and enamel perched
on them, which at a sign could be turned on and off.  There
were all sorts of other mechanical toys to make savages gape.
There was the Hippodrome, so much vaster and better
arranged than anything in the West, and the great churches
with their mosaics shimmering with gold like some strange
under-sea world.  There were elephants and camels and
lions ; there was rare merchandise from the far East to handle
and taste and smell and marvel at.  There were the special
treasures belonging to the Emperor himself, pearls and rubies
named but unpriceable, diadems and necklaces and cups.
Above all there were the Relics, each encased in its own
reliquary, itself a marvel of craftsmanship ; there were the
Nails, the Sponge, the Crown of Thorns, the Sandals, the
Winding Sheet, and that largest piece of all of the True
Cross ; there was the very precious Letter written by Christ,
unique in the world, captured two generations before as part
of the booty of Edessa.  Besides these, there were relics of

almost all the saints, parts of their clothes or bodies, taken in war from other cities or given in gratitude to the Emperor. However familiar the thought of them, they must have been impressive even to a Byzantine noble, even to the Emperor himself. And to the Crusaders they must surely have seemed a promise of their goal.

Raymond of St Gilles came next. Anna allows him a few virtues, prudence, sincerity and honesty, partly perhaps because he did not get on well with Bohemond. He would not, however, take the oath of fealty, which almost all the other chiefs did sooner or later. By May of 1097 Alexius had concluded a treaty with the Crusaders ; he was to be at their head and protect them in his own dominions, and to furnish troops for the expedition to Asia ; they were to give him back any of the towns which had formerly belonged to the Empire but had been captured by the Turks. Constantinople was left in comparative peace, and the Crusaders went over to Asia Minor to begin their long campaign for the taking of a still very distant Jerusalem.

We do not know much about Anna's life now ; for a time perhaps it was enviably calm. Her eldest son may have been born fairly soon, and she was certainly not one to think lightly of maternity or of any part of family life. Yet in all her history book she never mentions her children—the Emperor's grandchildren ; at first reading one would suppose, from matter and manner alike, that she was childless. I suppose the time came when even children were an added bitterness to her, another evidence of the thwarting of her ambition. But it is certain that she had at least two sons, one called Alexius after the Emperor, and two daughters. The Empress Irene's family name—Ducas—is used as well.

But if their names came from her, their placid and com-
fortable second-rateness came from their father. It seems
probable that she had at least one or two other children who
died in infancy, but that was expected in those days, no
terrible shock : religion and tradition alike went to help.
One cannot but think that, for a time at any rate, Anna was
happy ; the difficulty was that she could not store up happi-
ness and keep it from spoiling—her mind would not allow
that.

Her mother Irene had entirely replaced that first love,
Maria the Alan. They were never separated from one
another for long ; Bryennius was never jealous and never
tried to come between them. They must have been the
better friends, because there was so little difference of age—
when Anna was a woman and a mother herself, Irene was
not much over thirty. Anna had developed young in mind
and body, but Irene's ambitions had taken time and were only
now coming into form. They centred themselves about this
favourite and first-born daughter and the kind, polite, helpful
son-in-law, who had become so much one of the family.
And yet perhaps it might have been better for Anna if for a
time at least she could have had to do with someone who had
no ambitions and no grievances, or if Bryennius had been
strong enough to take her out of that atmosphere. But he
fitted in too well.

Her brother John was growing up now, a dark, secretive
boy. She did not like him any the better, nor did Irene.
Nobody knew what Alexius thought. That was so difficult
for everyone ! One might suppose one knew just where
one was, just where one would be in ten years, say ; but the
Emperor smiled and said nothing.

Among the pleasantest of the documents of this time are the two letters written home by Count Stephen of Blois, to his wife Adela, sweetest of friends. The first is from the camp of the besiegers of Nicæa. He is enthusiastic over Alexius, who received him very well and gave him the most splendid and costly presents. There is no one the Emperor likes better than the Count : he suggests they should send him out one of their sons. There is nobody like him under the sky ; he is always feasting rich and poor and giving presents !

A description of the various cities they have seen and of the siege of Nicæa follows. It is all written in stiff and formal Latin ; Stephen feels hampered by it—as if he could not write fast enough. It livens up almost more about Alexius than anywhere else. The second letter is later and all about battles with the Turks, whose barbarous names look out of place set in the other language. It is cheerful · on the whole ; there is a consciousness of ultimate victory, of the Holy City not too far off ; but they have had stiff fighting. At the end he says : ' I am only telling you very little, dearest, out of much that has happened.' I wonder what kind of idea of it all she had after getting the letters, and whether she thought of Constantinople as very different from Blois.

During the first year the Crusaders marched east and south, fighting the Turks and quarrelling with one another. As far as Antioch the Imperial troops went with them, but here Bohemond, intriguing with the Greek general, managed to get them withdrawn, and then proceeded to annex the town for himself as soon as the besiegers had won. Meanwhile Alexius had been setting out at the head of another

army, but was persuaded to turn back by some of the other leaders. All the time one gets the same picture of division and jealousy among the French counts who did most of the leading. Alliances were made and unmade ; the rumours that floated back to Constantinople must have been difficult to disentangle, and still harder to make history of after the lapse of thirty years. At any rate it was the Crusaders alone, disregarding Alexius, who marched on Jerusalem and finally took it.

One wonders if the Emperor and his friends were simply thankful at getting rid of this mob of barbarians or whether they would have liked to have helped with the deliverance of the Sepulchre. But perhaps it still seemed all very remote and unpractical.

# 5

## BOHEMOND

ALL THROUGH ANNA COMNENA'S history she
keeps up the contrast between Alexius and Bohemond, so
that sometimes it almost gives one the feeling of a single
combat. This is her central idea, her unity ; it is through
this that she can claim her tiny degree of kindred with Thucy-
dides. It must have been a few months after her marriage
that she first saw Bohemond, and after that she would have
seen him fairly often for some little time. Then he dis-
appeared into enmity, and she did not see him again for nearly
ten years. But she must have heard him spoken about very
often ; for her, he must have typified the whole of barbarism
and the forces that she could not understand breaking like
waves about the sea-worn Empire.

She describes him first as a character, making him com-
pletely the Norman adventurer, like his father but less brutal.
' He understood wonderfully well how to fit himself in with
times and occasions. He was subtler and bolder than one
can say. He surpassed the other Counts in cunning and
bravery, as much as they did him in riches and power. His
trickeries were an everlasting treasury for him. He showed
all the fickleness common to his nation in accepting presents,
sending them back, and taking them again. But still, he
could be very secret in his ways.'

The second description is of a Bohemond ten years older,
but not perceptibly altered ; she is not good enough historian
to make her characters develop, so it does as well for the
younger man. ' There has been no one else like him during
this century. He was taller than the tallest, narrow waisted
and hipped, but big across the back and chest, with great
strong arms : neither fat nor thin, but just as he should be,
just as Polycletos makes his statues—faithful copies of the
perfection of nature. His hands were broad and firm, his
feet solid. He bent his head a little modestly, as he had been
used to as a young man. His body was all white, but the
red came pleasantly on his face. He had hair, down over his
ears, but not sprawling barbarian-fashion on to his shoulders ;
I hardly know if his beard was red or some other colour, for
he was always close-shaven. His eyes were blue and seemed
both fierce and proud. His nostrils were open wide, for he
was so high-hearted he was bound to breathe great chestsful
of air to cool himself. There was something kind and charm-
ing about his expression, but his size and the look of pride he
had were somehow wild and terrible. His laughter was as
frightening as another man's anger ; he spoke well, too, and
was never at a loss for an answer.'

She can amuse herself at his expense too :—' Bohemond
waking up at the idea of presents ! ' She makes the Normans
out, if not a nation of shop-keepers, at least hard bargain
drivers and knowing very well what they wanted. Perhaps
it had sometimes been disappointing for the Greeks not to have
been subtle enough to take in the barbarians.

During all the quarrels with the Crusaders, and faith
broken on both sides, the Emperor seems always to have
blamed Bohemond and probably he had reason. The leader

he seems to have trusted most was Raymond of Toulouse.
One of the new arrivals was the Archbishop of Pisa with a
fleet which turned aside to some profitable pillaging of Greek
islands.   However, it was driven off the coast of Cyprus with
considerable loss.   The Lombard Crusade came next and
went on into Asia, where the Turks, really alarmed, managed
to unite at last, and attacked the expedition, which was cut to
pieces ; again, the survivors who got back to Constantinople
were not inclined to look favourably on the Emperor, though
he certainly seems not to have been responsible for this,
particularly as they never followed his advice about anything.
    It was essential that the Emperor should see for himself
just what was going on in his Empire ; there had been enough
governing from inside palace walls.   Nowadays he took the
Empress Irene about with him always ; it seems as if he was
getting quite unable to do without her, and she must have
begun to get the delightful feeling of power, although her
daughter often explains how distasteful to her it all was, how
much sooner she would have stayed at home, reading pious
books, giving alms, saving her soul in one way or another.
This may have been true at first and up to a point, but her
pleasure in her own growing ascendancy over the Emperor
must have begun to over-balance the joys of home fairly
rapidly.   Only, she would always have been wondering—and
asking Anna—how far it all went, how much she could count
on it.   Poor Alexius had gout, and she was his best nurse.
Besides, he could trust her to be his surest, least possibly
bribable guard, against all the constant plots and attempts on
his life that were everlastingly coming to the surface.   How
far he trusted her over other things was his own affair.
    Certainly Anna and Nicephorus Bryennius came with

him too, probably leaving their baby or babies at home, and one can be almost certain that Anna enjoyed it. Life in camp must have been interesting and even exciting, and Anna, with her solid, half scientific mind, liked more than almost anything the company of experts. She was nearly twenty now and full of ambition and curiosity, as is only right and natural at that age. There were plenty of young people of her own kind of standing ; they had their own beautifully fitted tents with plenty of attendants and the comforts they were used to at home ; it happened mostly in summer. I doubt if Anna had many out-of-door pastimes, but we know she played chess, sometimes with her father. It must have been a pleasure in itself to play on an elaborate Byzantine chess-board, made up with precious metals and enamel, and to make one's moves with pieces of such amazingly intricate craftsmanship.

But one imagines Anna most happily talking to the experts, handling their things, looking at plans and recipes. Once she describes a cross-bow, a weapon not known to the Greeks and only just coming into use in Western Europe, and I think she must herself have seen it worked : the man lying on his back with his feet against the half circle of the bow, straining with all his might at the cord that holds back the tube with the arrow in it ; and the short, iron-headed arrows that will go through any armour, pierce a man from front to back, kill him before he feels the blow. She says at the end that this machine is altogether worthy of the malice of demons, but all the same she has loved describing it !

Or again, when she is writing her long and elaborate description of Greek fire and how it is used, she knows very

well what she is about ; she has seen and smelt the stuff herself. It is not so clear to us, for she has no modern words for her basic materials ; sometimes it seems like gunpowder of some kind, sometimes more like naphtha or even petrol. The one thing that is quite certain is that there were many kinds of it, made up and used in different ways, and that the experts were constantly at work on new methods. The secrets of these horrors were carefully kept from foreigners and the uninitiated, but Anna was a princess and could see what she chose ; it seems likely that she did choose, that she went round the factories, inspected the *flammenwerfers* and all the ingenious devices for sea or land fighting, asking questions, setting her cool, matter-of-fact, thorough mind on to the concrete problems and getting everything answered satisfactorily before she went away.

She must have seen siege machines too, and catapults and rams, not only in design or stationary, but even in use ; for those were days when it was still safe to come within a reasonable distance of a battle or siege. Whenever there was a great building to be put up, church or hospital or palace, she would be one of those to visit the architect and probably make her own suggestions ; decoration interested her less. Astronomy interested her too, though here again she is practical and prefers an eclipse to be put to her father's use and made to alarm the unscientific barbarians ; comets demand a more elaborate explanation, and a certain degree of superstition seems only natural. She speaks of the physicians of her day as though she found them neither at all alarming nor impressive ; she seems to know nearly as much about the practice of medicine as they did, and is quite prepared to uphold her own theories.

It was after one of these expeditions of the Emperor's, on his homecoming, that a new conspiracy came to light. It was a difficult time and things had to be put down firmly. The four noble brothers chiefly concerned were condemned to have their heads shaved, their beards plucked out, to be dragged through the streets like this, and as usual then to have their eyes put out. During this horrid procession across the city they were wrapped in old sacks with sheep and ox entrails made disgustingly into mock turbans on their heads, and set, head to tail, on to ox-back. All round them there was dancing and laughter and dirty songs, and a nasty clamour of pleasure from the crowds. Even in the Palace they heard it, and Anna and her sisters crept over to a window to look on too for a half-guilty, half-thrilled moment. Michael Anemas, the eldest of the brothers, was being hauled along below ; he had been a fine young man, brave and handsome. He threw up his hands and eyes desperately for mercy; even that crowd were a little touched, and much more Anna who had known him in better days at the Court.

She sent, crying, for her mother, imploring her to come and see for herself what a dreadful, horrible thing was happening ; then she must go to the Emperor and beg for mercy ! But Irene did not come ; she and Alexius were in their chapel before the image of the Virgin, at prayers. Anna ran to the door and stood there in the doorway making signs to her mother ; she came at last, just in time, saw the poor Michael Anemas and was as much touched as the others. She began begging the Emperor to spare him his eyes at least, and finally he granted it, so long as the criminals were not past the Hands of Bronze and beyond mercy. The women sent messengers rushing off to stop the executioners.

These Hands of Bronze were fastened curiously and from old time, in the vault of an archway, and the rule was that any criminal could be pardoned before he got to them, but not afterwards. Michael was almost under them before the messengers arrived. He was imprisoned instead for a long time, but in the end was let out and taken back to favour by the Emperor ; so all was well. And Anna is happily sure that God inspired her directly to intercede for the brave young man and keep him his eyes.

In the meantime the combat between Alexius and Bohemond was preparing. Bohemond had been a prisoner among the Turks for two years, from 1100 to 1102 ; ransomed, he made open war against the Emperor, but could not fight two enemies at once, and found himself hemmed in between Greeks and Turks on the coast of Palestine. It was obvious that he could not fight the Empire from there ; he must get nearer its heart, and from the European side ; he had never given up his early ambition and still saw himself one day on the Throne. There was nothing so very fantastic about that ; only he was a hundred years too soon. It was not until 1204 that Baldwin of Flanders was crowned Latin Emperor of Constantinople.

However, Bohemond was besieged in Antioch by the Emperor's Generals and decided he must escape and get back to Europe ; the way he did it seems almost too good to be true. He had the rumour of his own death started, and then went off inside a coffin surrounded by mourners, on a galley which was allowed to pass freely through the Greek fleet. Anna makes it all very convincing by explaining how he had a dead and much stinking cock shut up with him so that there should be no suspicions, and goes on to explain how this

reaffirms her certainty that there is nothing too nasty and difficult for barbarians to do when they are once set on it. But at any rate, somehow or other he got back to Italy and started raising a really adequate force to attack the Empire. It ended by being a kind of New Crusade against Alexius himself, who was made out an even subtler and more dangerous Serpent than any turbaned and scimitared Moslem. Alexius undid some of the effects of Bohemond's propaganda by writing himself to Pisa, Genoa, Venice, and other City States of Italy, and also by sending to Babylon to ransom three hundred French counts who had been living miserably for years in the most orthodox kind of bread-and-water dungeons ; these in gratitude did something to counteract the new crusade.   The Pope seems to have been on Bohemond's side, partly perhaps tricked into thinking that the Greek armies were all made up of enemies of the Cross, because a few of the Patzinak or Cuman mercenaries who were captured and brought to him were certainly heathen.   There was a constant interchange of letters between the various potentates ;  probably one or two of the attempted assassinations of Alexius could be put down to the Norman.   By the autumn of 1107 Bohemond's new army, 34,000 strong, was ready to start.

His first landing was again at Durazzo, which he began to besiege.   The news came through to the Capital and arrived when the Emperor was away hunting.   One of these heathen Russians, the fastest messenger there was, was sent to find him on his way back from the hunt, and, flinging himself at the Imperial feet, gasped out that Bohemond was come.   But the Emperor dismounted and spoke gaily over his shoulder as he undid the cords of his hunting shoes : ' Let us come and

have dinner : afterwards we can think of a welcome for our
enemies ! '

He was as cheerful as this because he was not afraid ;
he knew what to do this time and had the men and money to
do it. He set off himself ' after being favoured by the usual
Miracle of the Church of Blaquernæ,' an unveiling of the
very holy Virgin there, which probably happened every
Friday. But he was absolutely determined not to fight a
battle. He sat down to enclose the Norman army by sea
and land and starve it out. Besides this, he managed a con-
siderable disturbance of Bohemond's morale by a very typical
piece of Comnenian strategy. He found out which of the
French counts were the most important and above all which
were Bohemond's best friends. Then he wrote letters made
to appear like answers to other treasonable letters sent to him
by these Counts, and then arranged that they should fall into
Bohemond's hands. It succeeded perfectly, and poor Bohe-
mond was left in the most horrid state of suspicion, unable
to trust any of his friends or even his brother Guy. By the
spring of 1108, after vainly trying to break out, Bohemond
was forced to admit his defeat.

It was all intensely humiliating for him. Part of his
army were taken prisoner, including a cousin of his own ten
feet high, at whom Anna was much amused ! Others had
deserted him. The Emperor's terms were hard ; he would
not take them at first. But in the end he had to. He was
made to start with repentance for his past actions : coming to
himself he must now make a quite new treaty for the future.
First he was forced to swear fealty to Alexius and his dear
son, John Porphyrogenitus. He must serve them himself
against their enemies ' so long as they are not invulnerable as

angels and have not bodies of steel.' If he cannot come himself he must send valiant and adequate substitutes, and his vassals must do the same. He may take oath to no one else, nor allow any to take oath to him except as the Emperor's representative. All former Imperial territories which he has conquered are to be given back to the Emperor, and any conquests he may make from Turks or Armenians are to be held by him only in fief. He is to send back any of the Emperor's subjects who wish to take service with him. He will declare war on his own nephew Tancred unless he restores the Greek towns which he is wrongfully holding. If the treaty is broken the subjects of his towns have the right of trying for forty days to bring him back to his duty ; failing that, they are to desert him and go over to the Emperor. Those who are with him are to take the same oath, the rest of his armies will give it at Antioch to whomsoever the Emperor shall be pleased to appoint. Those newly come from the West who refuse to take it shall not be allowed to cross the seas. The Emperor has the right to appoint the Patriarch of Antioch not only from the Greek Church, but from his almost domestic clergy of Constantinople.

In return for all this, the Emperor will make over to him the territories which he holds already round Antioch—it would have been extremely difficult to do anything else—and allow him to name his own heir. But many of the outlying territories, which he is to hold during his lifetime, and which are all named very carefully and thoroughly in the treaty itself, confirmed by letters sealed with the Golden Seal, are to go back to the Emperor or his successor after Bohemond's death. However, he is left a very adequate principality,

enough for the honour of the West, far more than would have
seemed possible to him at one time.

The Emperor was as considerate as possible. He received
Bohemond as he had insisted on being received, almost as an
equal, without any too obsequious bowings and kneelings.
He sat him down on a seat beside the throne. Perhaps some
of the courtiers were distressed by this departure from the
proper ceremonial, but not, I think, Bryennius. And the
Emperor himself was too much of a realist to care. He knew
that he was gaining immensely out of it all, he had at last
dealt with the enemy of half his lifetime. So the barbarian
might as well have such courtesies as he might care for, some-
thing at least to take back to his wife and children and the
obscure poets and chroniclers of France.

Besides this reception, Bohemond was given the title of
Sebastos, quantities of presents, and much money. But
nothing could take him out of the profound depression that
the wreck of his hopes had left him in. Perhaps he got some
little sympathy and friendship from Nicephorus Bryennius,
the only one of the Emperor's court he seemed to care to talk
with or would allow to take his hand in sincerity. Anna
must have seen him then with her husband and may have
felt friendly and even pitiful herself; but certainly she was
never anything but a distant and hieratic princess to Bohe-
mond. The treaty was very long; it must have seemed
hours before the reading of it came to an end, other hours
before it was signed by all the notables on each side. Bohe-
mond swore to it on the Gospels, and on the lance head that
had pierced Christ's side. He must have been utterly tired
out before the end.

I wonder whether, either then, or that time ten years

before when he was in Constantinople for some weeks at least, he ever tried to see his sister Helen. Perhaps he thought it was best to forget her ; she was not really an adequate excuse for anything any longer. And most likely he scarcely remembered her at all from childhood ; they had both been so young.

It was very probably during these months of waiting and haggling over terms that Anna had her chance of observing the French armour which she describes so well—scale armour and a polished buckler against which arrows are little use. She makes her criticism of the armies of chivalry : 'A French-man on a good horse certainly moves with such force that nothing can stand against him. Like this, he can throw down the walls of Babylon itself ; but once unhorsed the most ordinary soldier can deal with him.' That perhaps embodied the essential piece of tactics against any Western army of the age of chivalry ; this was how later battles were won.

After the signing of the treaty there was nothing left for Bohemond. All his life had been in pursuit of one ambition ; now that was impossible he could see no future for himself. He was tired of armies ; he left his men to the Emperor, who promised he would see to the supplies through the coming winter and then let them go where they would. Then, as quickly as he could he turned his back on it all, and took ship for Italy. Here, not long afterwards, he died. And Anna's history book, at least, is the poorer for his death.

# 6

## JOHN

THE HEIR TO THE EMPIRE, Alexius' eldest son, John
Porphyrogenitus, was married about 1103 to the Princess
Prisca of Hungary. It is remarkable how completely his
sister omits what must have been at least an impressive and
highly coloured ceremony, an event even for that eventful
Capital, where it must have happened. The next year,
they had twins : ' at the age of sixteen he was father of a
son.' He seems to have gone on leading a not wildly exciting
life, but a sober and reasonable one, which at any rate gained
over to his side—against the time when there would be need—
most of the more sensible people. But never his own mother.
She went on all her life considering him as all the things a
Byzantine prince very often was, but which he had escaped
being : dissolute, light-minded, corrupt, unbalanced. Once
he realised this, his dislike and distrust of her became equally
great ; it included his sister Anna, and perhaps to some extent
her husband Bryennius. And with this there was a growing
friendship between him and his father, a queer half-secret
thing that they kept firmly from the women.

In the treaty with Bohemond, John is mentioned every
time his father is ; any oath is an oath to him too. That
must have been disquieting enough for Irene and Anna ;
perhaps the kind and gentle Bryennius soothed them down,

playing woman to them when their ambitions had made them
rather too much like the worser men of that epoch.  As the
Imperial family grew up it began to take sides.  The second
sister Maria and the third brother Andronicus were on Anna's
side.  But the second brother Isaac sided with John, and so
probably did the two younger sisters.  From the time she
was twenty-five, one sees Anna gradually hardening, letting
her passions all go one way to one goal, and losing the balance
of her life.  There was no one to put her right ; Bryennius
never quite had the courage to ; besides, wasn't it him she
was working for ?  Shouldn't he be grateful ?  Mightn't he
too sometimes have been blinded by that luring of the Purple,
and thought that after all it was possible that the Emperor
might set aside John and choose not one of his other sons,
but his son-in-law, husband of his eldest child ?

Certainly nobody could tell with Alexius.  Bryennius
was constantly with him in peace or war, at every council and
every meeting of the Court.  He seems to have been more
relied on than anyone else—unless John ?  How hard Irene
must have tried to find out !

After the treaty of 1108 there was no more war with the
West, though the Crusaders who had stayed and made them-
selves Eastern princes were a fairly constant source of small
difficulties.  But there was more and serious war with the
Turks who united again under the great Seljuq prince Malik
Shah.  On the whole the Emperor won any pitched battle,
but in the meantime the fertile valleys of Asia Minor were
being pillaged year after year by the Turkish raiders.  There
was another northern invasion of Cumans too, though this
was beaten off.  It gave Alexius the opportunity of staying
in Philippopolis, the obvious town from which to watch the

north, and arguing during all his leisure time with the Manicheans who lived up there.

These Manicheans were one of the earliest sects or heretics and they went on for a very long time, dividing up of course into various branches. Their main belief was in the two principles of good and evil, personified on one side by God and Christ, on the other by various demons and powers of ill. It seems a very natural and reasonable idea, which, in one form or another, has been, and is, much held. It is obviously at the base of much modern belief; Persian in origin, it goes well with the combative spirit of Western and Northern Europe. Mr Wells, for instance, would almost certainly have been taken for one of the sect in the days when the name still meant something, and so, I think, would many prominent members of the Church of England.

Various other principles became incorporated with Manicheism at one time or another, the idea, for instance, of the good principle—light, life—trying to get away from gross matter, so that the begetting of children merely continued the captivity of souls. The Manicheans were the first protestants, speaking boldly against the adoration of ikons and the cross. Two and a half centuries earlier they had been terribly persecuted by the then Empress, tortured and crucified. So, not unnaturally, they had turned against the Empire. During the tenth century a number of them had been transported into the country south of the Danube and were allowed a fair amount of religious liberty. They were brave and warlike, not crushed by constant persecution, and many Emperors had realised what good soldiers they made. It would have been a great thing for Alexius, the thirteenth apostle, as Anna calls him, comparing him with Constantine

(not on the whole a person one would like to be compared
with, but tastes differ through the ages), if he could have
really converted them.

Anna certainly thought he did. She talks about them a
great deal. At one time she thinks of writing a refutation
of their dogmas, but then considers that all the world—all her
world—knows better and laughs at them already. Besides
the rules of History do not allow for digressions with the sister
muse Theology, even when she is most powerful. But
there is great and sincere enthusiasm over her father and his
efforts.

He preferred dealing with his own heresies always. He
argued night and day with the Manicheans and Paulicians,
who were very much the same thing under a different name,
either in person, or with the help of Bryennius, who was a
good theologian as well, and two bishops. It is scarcely
remarkable that a number of heretics were converted,
hundreds of them every day. One admires the courage of
the three leaders who stood out against the Emperor for a
long time. Even so, only two of them were finally found
quite obdurate, ' as hard as anvils,' and they were imprisoned
for life, so that ' they could do no harm except to themselves.'

Anna was probably not present at these sittings, but she,
and perhaps her mother too, were up in Philippopolis. She
is moved to real transports of enthusiasm by its romantic
beauties among these northern mountains and torrents. It
was full of fine buildings as well, and she obviously enjoyed
her stay there ; it must have been one of her pleasantest
changes from Constantinople.

The arguments were interrupted by fighting with the
Cumans. But on the whole wars still went on mostly in

summer. This was so through most of the last years of the Emperor. He, and with him Irene, Anna and Bryennius, could pass the winter either at the Capital or at some other civilised place. Here there was all the business of justice, which the Emperor still attended to in person whenever possible ; anyone could appeal to him, and this was perhaps cheaper than going to a judge who might have to be bribed. Sometimes he hunted, or played tennis ; later on as his health grew worse he took as much exercise as possible, running for instance. He read a great deal, mostly in the sacred books, and attended much to his devotions. He had to make official appearances at the Hippodrome and would have enjoyed the horse and chariot racing ; he was a good rider himself. And all the time the intensely elaborate pattern of Court life made and unmade itself all round him.

Foreigners of all sorts were constantly appearing and having to be received. In the spring of 1111, Sigurd of Norway came through. It was essential to be as polite as possible to him, because of the Varangians, for many of whom he was something better than any Emperor. We hear all about it in his own story, the saga of Sigurd Magnusson, written down in the 13th century from earlier sources, some reasonably accurate, others very legendary. He was on his way back from Jerusalem where King Baldwin had given hospitality to him and his folk ; they had repaid it well by helping their host to take Sidon, and he had given them many precious relics, among them a splinter from the True Cross. The story goes on to tell how Kaiser Kyrialax (who is Alexius rather badly muddled) had the Golden Gate of Micklegard unlocked for them, and how King Sigurd bade his men ride proudly into the city through the streets

F

hung with purple, and not stare at all the new things they
saw.

Then they were shown the Games in the Hippodrome.
According to the saga one side in the Games belonged to the
Emperor, the other to his Queen, and if the Emperor won,
as he did this time, that was a good omen for victory in war.
All along the walls of the Hippodrome were carvings of old
time, Gods and heroes, so cunningly done that men thought
them to be living. One day King Sigurd wished to give a
feast to the Emperor and sent out for all the best of every-
thing ; but when it came to firewood they could get none
in the whole city, so the King bade them get walnuts and
use them for their fires. Now the Queen—Irene—had
made this lack of firewood to test King Sigurd, and when she
heard what had happened and how he had bought a whole
houseful of walnuts for firing, she said that the King was
indeed a man of honour and high condition : and all went
well at that feast. So the story goes.

After that there was a great exchange of presents, gold
and silver and horses ; King Sigurd left all his ships, for he
would go back by land, and many of his men, who entered
the Emperor's service as Varangians. He was twenty
years old then. One wishes Anna had noticed him, left
some sort of portrait of him, but I suppose he was only just
another barbarian.

Then there were the children to bring up. Anna pro-
bably began early arranging a marriage for her eldest son,
considering what Augustness he might be going to be !
As was very usual a foreign princess was brought to
Constantinople as a child, and given to Anna to be educated
into the perfect daughter-in-law. And of course there was

always religion, as there always had been, ever since Con-
stantine's time.

Alexius kept up a correspondence with the Pope, and
seems really to have tried to produce some union between
the Eastern and Western Churches, but things went slowly,
and nothing came of it.   In the end nothing much came of
the conversion of the Manicheans either.   They relapsed as
soon as they decently could.   In Gibbon's time there were
still Paulicians of a sort in the district, and they were the
spiritual fathers of many other heretics, among others the
Albigeois of the twelfth century.   As time went on they were
persecuted more and more brutally and bloodily ;   the latest
Manicheans, or earliest protestants, struggling against terrible
odds up in the north, branded and whipped and burnt alive,
would have thought Alexius' methods of conversion very
merciful.

The other chief brand of heretic, spiritually related to the
Manicheans, though on the whole perhaps less intellectual,
were the Hypocritical Bogomils, about whose practices it was
not quite nice to talk.   Anna is considerably more violent
about them and calls them wolves in sheep's clothing.   Many
of them were converted in the same manner, but their head,
a monk called Basil, was too tough for ordinary treatment.
Besides, the thing had spread into the Clergy and all sorts of
noble families were involved ;   an example was necessary.
Basil was finally given the choice of an orthodox cross to
adore, or burning alive.   Crowds of his followers came to
watch, to see the miracle happen and their leader snatched out
of the fire by angels ;   crowds of the faithful came too ;   there
was room for them all because it happened in the Hippo-
drome.   The Emperor looked on, frowning.   The terrible

pyre was lit.    But Basil wickedly remained obdurate, 'in
brutish stupidity.'    They tried the fire on his cloak, which
should have stayed unburnt if the Bogomils had the truth ;
in fact Basil himself cried out :   'You see, my cloak has not
been burnt—it flies through the air  ! '    But at this the execu-
tioners, and most likely Alexius too, up on his throne, lost
patience, and the monk was suddenly seized and thrown on
to the fire himself and burnt with the cloak.    So that was
the end of that heresy ;  by more modern standards a single
burning alive is not very much.

The Emperor was beginning to be an old man now.    His
mother died, and his brother Isaac died too, leaving a family
of young children, of whom Alexius took every care.    His
youngest son Andronicus was killed in battle, much to Anna's
distress.    Every year the Emperor found his health getting
worse ;  he often had to stay in bed for days at a time.    While
this happened, Irene did the governing.    She was not
popular ;  the stiffness of her childhood had never quite worn
off.    Zonaras calls her ' proud and haughty, standing sharply
on her dignity.'    Bryennius was a great power too ;  he was
just and well esteemed and his judgments were taken as being
equally sound and valid as the Emperor's own.    And all
the time, both openly and secretly, the struggle with John
went on, and Irene, getting more and more violently one-
sided about it, probably did not scruple to use any means to
discredit her son, and, when possible, over-rule anything he
wanted.    But all the same, the best part of Constantinople
was with him.

One of the things which occupied Alexius' last year or
two was the great hospital and grammar school which he
founded and endowed, in a new model town which he had

built on the outskirts of the city. Anna describes it with
enthusiasm. It was two stories high and so big that one
could scarcely see it all in a day. Alexius had endowed it
with lands all over the Empire, whose products were sold,
partly for the maintenance of the sick folk and orphans, and
partly for the church of St Paul with which it was associated
and whose monks looked after the wards. Certain sums
every year went towards candles and two magnificent choirs.
No doubt the Emperor was now thinking much of laying
up for himself treasure in heaven, but he was also a genuinely
humane man. All these wars had produced plenty of blind
men, and cripples, besides the usual crop one would see in any
large town ; there were many orphans, too, of all kinds of
nationalities, who were well educated, as things went. It
became one of the sights of the town, and the funds were
probably added to by successive benefactors. Alexius was
also conspicuously humane to his prisoners of war, and to all
sorts of camp followers and persons of no importance. When
his armies were on the march he did all that was possible for
the women, as well as for the sick and dying. His arrange-
ments were both kind and practical, just what appealed to
Anna. He distributed food from his own tables to the needy
and saw to it that the dead were decently buried. And of
course he always took care to provide suitably for widows or
young orphan children among his own relatives.

   But he was a sick man ; the disease, whatever it was,
which Anna describes as gout and which seems, according
to her, to have had its origin partly in old strains and bruises,
and partly through having to talk too much to these madden-
ing Frenchmen, had taken hold of him. Everyone grew
anxious ; he was seventy years old. He found it hard to

breathe, and hard to support patiently all that the various doctors wanted to do to him, horrible purges and cauteries. His pulse was irregular, he had pains about the heart, he could not lie comfortably on either side ; he could hardly sleep and had no appetite. They bled him, of course, but to no effect. He liked to be moved about from place to place and to have his position in bed changed very often. His wife and daughters saw to everything themselves and nursed him devotedly even while the backs of their minds were inevitably thinking about his successor. Meanwhile all the churches were full of prayers and candles, and alms were being distributed to the poor and prisoners. No one in the Capital could think of very much else ; it had been a long time since the death of an Emperor had not meant the most painful and exhausting disturbances, if not some sort of a revolution with bloodshed, and it was well enough known how things stood between Irene and John. There were several predictions of the death of the Emperor going about, though he himself had been cheered a little by the monks who promised him life until at least he had been to Jerusalem to adore the Sepulchre.

But his feet and belly were terribly swollen, and he could scarcely swallow ; Anna managed sometimes to feed him drop by drop, but he grew more and more feeble, and after eleven days of this the doctors gave up hope. Anna and her sisters were amazingly practical and on the whole calm, but the distracted Empress grew so hysterical that Alexius himself had to speak to her and calm her down. Poor Anna between a dying father and a hysterical mother had need of all her philosophy. It was the fifteenth of August, 1118, and the Emperor was now beyond speech. They were in a westward-facing room of the smaller

palace, and while they were there, Anna says, ' the successor
of the Empire took possession of the Great Palace ; the
people were somewhat horrified but did nothing to stop him.'
But Zonaras tells a rather different story of John, and so
does the more malicious Nicetas.   When he was told that
his father was really dying, he went up to his bed, and bent
over him weeping, but took the seal ring—the symbol of
authority—off his finger, and hurried away with it.    And
whether Alexius knew and approved of this, nobody can tell
for certain.   Only, when the Empress understood what had
happened she flung herself on to the dying man, crying out
that their son was having himself wickedly proclaimed
Emperor while his father was alive !—this John whom she
had always warned him against !   What would he do now ?
But he only smiled a little mockingly at her and lifted his
eyes and feeble hands a little ; and it seems more likely that
this was a blessing rather than a cursing of John.   But he
said nothing at all.   And Nicetas says that she stood up and
sighed and said : ' You faithless husband, whose tongue and
heart have never been the same, even now that you are
almost dead you cannot stop your lying ! '
        Anna says nothing of all this ; the only picture is of her
standing beside her father with a finger on the failing pulse,
and her sister Maria trying to shield the Empress from seeing
too much.   But Irene, sobbing and screaming, threw off all
the ornaments of an Empress, cut all her hair, and even before
he died was all in black, borrowed from her widowed daughter
Maria, since there was no other in the Palace.   But how
much because of her husband and how much because of her
son ?   So towards midnight the Emperor did die and it was
another Jerusalem he went to worship in.

One can say at least that the description of the Emperor's death is the best piece of writing in the whole of the *Alexiad*, the most moving and convincing of all her work. One dare not say that, because of this, it is necessarily good history, only perhaps that one would sooner believe her than Nicetas. It is one of the few bits of really adequate narrative in which she is herself an actor ; it has dignity and pathos, but is yet not copied from any great model. Sometimes it almost comes near to real tragedy.

It is very possible that both pictures are true, as far as they go. Because, under the stress of violent emotion and the intense weariness of days and nights of anxiety and varied hope, the human mind splits up and the rational being we know and count on, who is always bringing in common sense or some kind of judgment to help now one side and now the other of its nature, disappears, and instead are left the two consistent but unrecognisable halves that had gone to make up the whole. By-and-by they join up again, but for the time they have been taking turns in governing the body they knew. If it was this that happened to Irene, then Anna saw the half that seemed to her to be really her mother, and ignored the other, as being for the moment mad and not real ; but some who were there or heard of it later, thought as they wished to think—the other way. Neither is right alone, and we must judge for ourselves which is nearer the true Empress.

It is here that Anna ends her own history book, and here indeed that much of her life ended. But it is not all that happened. There are the Varangian guards who will not let John into the Palace until they know for certain that their old master to whom they swore faith is truly dead. There

is the curiously hurried and unimpressive funeral of the late Emperor, with the new one too uncertain of his power to be able, in spite of his mother's invitation, to leave his palace and follow his father to the grave. There are all the new titles and offices to be given out, John on the whole following his affections for good, the best of friends until treachery made it impossible with his younger brother, and allowing himself to be counselled by one who had been a slave—John Axuch, a Persian prisoner who had been brought up with him and who seems somehow to have managed to be a really good man.

But Anna had not finished yet. In the spring of the next year she arranged a vast plot to assassinate her brother and have Nicephorus Bryennius made Emperor instead of him. It is doubtful how much hand Irene had in this ; she was discouraged now, and old ; it was better to leave things alone once they had been established. But there were plenty of others ready to conspire, and most likely they would have been successful, but for Bryennius himself. Nicetas says he arrived late. If he did one suspects him of having done it on purpose ; he had never been entirely ruled by Anna and Irene ; he asserted himself just in time, and refused to become a crime-stained Emperor just because his wife so much desired to be an Empress.

If it was really on purpose that he defeated the conspiracy it was a brave thing for him to do. Everyone was seized and brought to the Emperor for punishment. He, more merciful than his century, simply took away all their goods, and even so it was only for a time. He gave everything that had belonged to Anna to John Axuch the Persian ; but he would not take it, and persuaded the Emperor to give it back to his sister.

One wonders what sort of life Anna and Bryennius led together after this.   She seems to have lost her temper furiously with him after the failure of the plot.   Certainly there was her eldest son, and John seems again to have behaved remarkably well about this boy, going on with the marriage to the Princess of Abasgia, which Anna had been arranging at the time of her father's death.   Later on there were grandchildren, a boy and a girl ; neither of them appears to have been very interesting or beautiful, and Anna would have been a critical grandmother.   The granddaughter seems to have made a mésalliance with an imperial private secretary, and was forcibly pulled out of it, but we do not know whether this was still in Anna's time.   The grandson Andronicus became Prefect of Thessalonica and should have had a career of importance, but he was blinded on suspicion by the then Emperor ; and his son, first fleeing for refuge and then proclaimed Emperor himself by one of the many Constantinople mobs, was blinded too, soon afterwards.   Or so, at least, the chroniclers say.   But that was all much later.

At first Anna probably had to bear some kind of half imprisonment in her own palace, shut off from other possible conspirators.   Later she and her mother both retired to the convent they had been interested in all their lives, always perhaps thinking of it as at least a possible refuge for old age. Her daughters retired with her, though not to become nuns or anything of that sort, merely to complete their education. One hopes they were satisfactory and could quote in the proper way from the classics.   Most probably they, and the other son, married too.   But it is all rather obscure and difficult, and seems unimportant, though one cannot believe that it really was to Anna, still less to her husband while he lived.

John appears never to have lost faith in Bryennius, but
went on employing him on the most difficult campaigns,
including the very necessary one against Antioch, after which
an important treaty was made with Raymond who had
married Bohemond's heiress Constance.    This was in 1137.
Bryennius had already begun, at the old Empress' request, to
write a life of his father-in-law, and went on working at
it during the long dull stretches of siege and negotiation.
But he came back mortally ill and with his history only half
finished.    He died soon, and not long afterwards Irene died.
So Anna was left alone, nearing fifty and with little position,
no one much to order about, no one to console her, and that
wicked brother John showing himself—for it must have been
plain even to her—one of the justest and most competent
Emperors there had ever been on the difficult throne of Con-
stantinople.

So, after a time, she took up her husband's incomplete
work and went on with it, diving back into memories that
cannot, in spite of all she says, have been so very bitter after
the years and years that had gone by.    At first she had some
difficulty in getting at the official records ; she complains of
this herself.    But after a time she ceased to be looked on as a
dangerous person ; she was allowed to spend as long as she
liked in the Palace copying letters and Treaties, comparing
documents, taking notes.    Besides, her history book would
have involved a great deal of visiting ; she would have sat
in half state, as much a princess as possible, and received her
father's old generals, such as were alive still, and asked them
questions and had her secretary in to take down their stories.
They would talk over together the campaigns through which
she herself had been with the old Emperor, discuss tactics,

consider the improvement of siege machines, remember the curious habits of the barbarians.  Probably the last ten years of her life were not unhappy, for these things must have been a not too bad substitute for all she had wanted earlier—those dreams which were a little too faded by now to spoil such reality as there was.  Then, chapter by chapter, there would have been the reading over of her history book, the admiring friends, the old Generals delighted to listen to the sound of their own names, paying elaborate compliments to the faded princess.  There would have been decorous laughter at her jokes—for I suppose they were meant to bring a light relief— the simile of the lobster that could never go straight, which she uses twice, and the various acidly amusing references to Crusaders.  She would have liked approving comment on all her moral digressions : her remarks on true courage as practised by the Comneni, which included rather a lot of prudence and judgment and the avoiding of obstacles : the folly of superstition (although of course there were certain things which any sensible person would allow to influence his decisions) : and the state of the Church.

She had, I suppose, few literary competitors ; nothing wild or fantastic was being written.  The only style which mattered was the good old Attic—here again Anna would modestly wait for approval.  She was certainly well thought of by some at least of her contemporaries ; Zonaras says : ' She could speak Attic Greek very learnedly, and easily understood all the most difficult sentences and examples : this as much through her excellent intelligence as through her industry and diligence.'  No doubt she knew and talked with most of the learned men of her time ; there must have been long, pleasant, learned wrangles, enough to heat the blood of an aging literary lady.

She would have been an alarming person for the younger generation to meet, old Aunt Anna whom one went dutifully to see from time to time at her nunnery, and who was so ridiculously severe and old-fashioned about everything, and talked about times and politics no one was interested in now. But doubtless if one really wanted advice about anything, hers would be excellent, and she must have had her finger in a lot of family pies, and had been God-mother to many children. Perhaps sometimes she would even tell stories, better than she wrote them, because more naturally, without thinking of the best models all the time, stories of adventures in war, the scandals of fifty years—all the frivolous things she could not possibly have put into a history book. And then perhaps she would talk about her childhood and Constantine the fairy prince, and one would have to think hard before one remembered who that was.

One day they came and told Anna that her brother John was dead, accidentally and tragically killed by a poisoned arrow on a hunting party. But no one knows what she thought of that, whether her long-twisted mind was still bitter enough to be glad, or whether possibly she was by that time good enough historian to see what the Empire had lost in John. That was in 1143, and she died herself about five years later, in 1148 as far as one knows. But no one took any account of it or put into any of their chronicles the death of an old Princess.

# BIBLIOGRAPHY

## I. Ancient

Anna Comnena, *History of the Emperor Alexius.*
Nicephorus Bryennius, *History of the Emperors:* Constantine Ducas to *Nicephorus Botaniates.*
Johannes Zonaras, Annals : Part II, *Empire of Alexius Comnenus.*
Nicetas Acominatus, *History of the Emperor John Comnenus.*

For background there is Michael Psellus' History, as well as various people, mostly in rather pleasant dog Latin, in the *Recueil des Historiens des Croisades: Historiens Occidentaux.*
Anna Comnena, Bryennius and Nicetas have been translated into French by Cousin during the seventeenth century; the translation is charming, but not very accurate. Zonaras has also been translated into French, but earlier, and the book is hard to come by. A new and thorough translation of Anna's History, *The Alexiad,* by Elizabeth A. S. Dawes, will be published shortly.

## II. Modern

Chalandon, *Alexis I Comnène.*
*Cambridge Mediæval History,* Vol. IV, Chapter XI.
Gibbon, *Decline and Fall of the Roman Empire,* Vol. V, Chapter XLVIII.
Diehl, *Figures Byzantines.*
Sommerand, *Deux Princesses a'Orient au XIIᵉ siècle.*

But a new book about Anna, published by the Oxford University Press, will be coming out this summer : *Anna Comnena,* by Georgina G. Buckler. This book is at present still in proof, though Mrs Buckler has most kindly answered various questions on points which I particularly wanted to know about. However, I hope that any of my readers who want to know more, and more authoritatively, about Anna, will go to this book. If the information they want is anywhere, I am sure it will be there, and I only hope they will not discover that anything I have written here is absolutely wrong ! There are a number of books which help to fill in the background. Perhaps those that have been most use to me are :

# BIBLIOGRAPHY

Schlumberger, *L'Epopée byzantine* : Part III.
*Cambridge Mediæval History*, Vols. III and V, and the rest of Vol. IV.
Helen Waddell, *Wandering Scholars*.
Schlumberger, *Récits de Byzance et Des Croisades*.

I should particularly like to thank Mr Stroud Read for standing up for the Byzantines, lending me books, answering questions, and for the doubtful service of encouraging me to write this.

N. M.